Growing Up in
FAIRFIELD
CALIFORNIA

To Roger,

7/30/2022

Growing Up in
FAIRFIELD
CALIFORNIA

Fairfield Rocks!
Enjoy!
Tony Wade

TONY WADE

THE
History
PRESS

Published by The History Press
Charleston, SC
www.historypress.com

Front cover, clockwise from top left: downtown Fairfield. *Courtesy of the Tim Farmer collection*; the Wonder World Shopping Center. *1967 Fairfield High yearbook*; Union Avenue in Fairfield. *Courtesy of the Armijo Alumni Association*; Foster's "Old-Fashion" Freeze. *1980 Armijo High yearbook.*
Back cover, left: Dave's Giant Hamburger. *Courtesy of Donna Covey Paintings*; *right*: Holland Dairy. *1977 Armijo High yearbook.*

First published 2021

Manufactured in the United States

ISBN 9781467149105

Library of Congress Control Number: 2021941042

To my wonderful wife, Beth, for her love and support; to the memory of Matt Garcia, which continues to inspire me to try to bloom where I am planted; to the members of the "I Grew Up in Fairfield Too" Facebook group for their poignant/humorous/thought-provoking contributions; and to all Fairfielders past and present.

CONTENTS

PREFACE

There are places I'll remember
All my life, though some have changed
Some forever, not for better
Some have gone, and some remain
All these places had their moments
With lovers and friends, I still can recall
Some are dead and some are living
In my life, I've loved them all
—The Beatles, "In My Life"

*W*hile these days I should probably consider pursuing help from a twelve-step group for Facebook addiction, back in 2009, I resisted joining the rapidly swelling ranks of members of the social media juggernaut. I kept getting emailed requests from friends to sign up, but I had successfully avoided the fad of Myspace for years and was determined to wait this one out as well. I don't remember exactly what my reluctance was or what eventually made me voluntarily paint all my red flags white, but one day I joined and instantly became hooked.

Connecting with friends I had not seen since childhood and finding people with shared interests was revelatory. But what cemented my love for Facebook—well, besides the cat videos—was when, in 2011, I stumbled across a group called "I Grew Up in Fairfield Too," created by longtime Fairfielder Rick Williams. These sorts of groups are ubiquitous on Facebook

now. Using the irresistible thread of nostalgia, they stitch together residents of places all over the country and the world.

As of this writing, time travel is still science fiction, but the "I Grew Up in Fairfield Too" Facebook group is the closest I've come to a DeLorean outfitted with a flux capacitor. The three thousand or so members of the group at the time were posting and commenting on places and events that included ones I remembered, ones that I had forgotten about and many that I had never heard of—the latter because they were from eras predating my own experiences.

I realized almost immediately that the shared virtual memory dance taking place was a relatively new phenomenon. Before Facebook, let's say I walked into a Fairfield eating establishment like Dave's Giant Hamburgers, which has been around since 1963. If while I was waiting for my cheeseburger (with grilled, not raw, onions) I overheard three septuagenarians sitting at a table talking about old Fairfield businesses like Ardan or Smorga Bob's, I probably wouldn't join in on their conversation.

Even though I had memories of both of those places and my synapses were firing, social conventions would keep me from chiming in on strangers' conversation.

However, in Facebook nostalgia groups, that kind of mass participation by strangers is the point! It's a (relatively) safe space to take a deep dive into the collective pool of memory of days gone by and to invite others in as well. In fact, without doing any kind of search, I am certain that the top three words posted in that group and in similar ones is "Does anyone remember?"

The answer is usually an emphatic "Yes!" I've experienced how shockingly thrilling it can be for people to talk about something as seemingly benign as a shoe store. But undergirding memories of past local businesses' mundane characteristics like their physical location and the goods or services they provided are often much more personal details. For example, going to Kinney Shoes with your mother (now deceased) and taking in the fresh scent of the new shoes there and the attendants measuring your foot in that measuring thingie. Other memories may include what it was like on your first day of school wearing your brand-new Chuck Taylors or Buster Browns. That sort of thing.

At the time I joined the "I Grew Up in Fairfield Too" group, I had been writing a weekly humor column in the Fairfield, California newspaper the *Daily Republic* for about four years. It gave me an idea to do a second column called Back in the Day that I pitched to the newspaper's powers that be as "kinda, sorta based on local history."

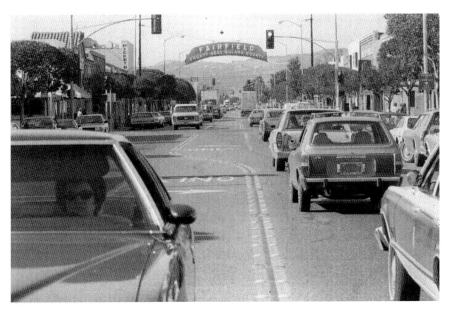

Downtown Fairfield with the iconic sign hanging over Texas Street in the 1970s. *Tim Farmer collection.*

Having a newspaper column about local history was not a new idea. Two former *Daily Republic* reporters in particular, Barry Eberling and Ian Thompson, wrote articles from time to time that I always enjoyed. But that kind of history wasn't what I was (primarily) interested in writing about. I wanted to focus for the most part on things that happened in the not-too-distant past and that you would *never read about in a history book* (cue the Alanis Morissette song "Ironic").

My family moved to Fairfield in 1976. Some of the things that I remembered from our earliest days here, like Eucalyptus Records and Tapes and Wonder World, were being posted in the Fairfield group. But they yielded zero results when they were Googled. I vowed to change that.

More important, taking my cue from the participatory nature of Facebook, I wanted also to include firsthand remembrances from folks whose lives were enriched by experiences at places that now exist only in memory. Delving into the past doesn't always have to be about the macro-history of how governments work or how economies flourish or fail. It can also include the micro-history of remembering things that helped to shape the people of a certain time living in a certain place.

I knew there would be a local appetite for that, especially since my columns are not written in some haughty history professor voice. I mean,

I am much more of a *humor*ian than a historian. In fact, in my bylines, I call myself an "accidental local historian." Once the Back in the Day column was greenlighted, I honestly was a little terrified. What the heck did I actually know about writing a history column? Well, what I didn't know I learned by trial and error. I have mainly always just tried to write columns that I would like to read.

I've made mistakes. I mean, jeez, my very first column referred to the founder of Fairfield, Captain Robert Waterman, as *General* Waterman. Oy. I also quickly learned not to just accept and trust anyone's memories—including my own. Memory is a weirdly subjective thing and is not to be trusted. Years ago, I wrote a column about a beautiful eight-hundred-seat auditorium that used to be in Fairfield. It had grown decrepit and was the subject of an ultimately unsuccessful local fight to save it. I asked numerous people when it was demolished and got dozens of answers. Everyone was 100 percent sure they were correct. None of them were. I now try to rely on primary-source documents when I can get them.

The more than 450 Back in the Day columns I have now written cover many topics, and my first rule of thumb is that I not take myself too seriously. That's partly why my inaugural column was about the Fairfield Area Rapid Transit (FART) buses.

While words are what I dabble in, I also know the incredible power that images have to stir memories. That was illustrated to me vividly years ago when I was writing about Fairfield's old Sambo's restaurant. A friend had given me several old photos to use for the column, and I decided to post some to the "I Grew Up in Fairfield Too" group. One was of a waitress near a coffee pot. It was a little blurry, and I almost didn't post it but ultimately did. Minutes later, someone excitedly recognized the waitress as their now-deceased aunt. They hadn't known that the picture existed and tagged a bunch of people and soon had a mini virtual family reunion right there in the group.

While I can string one word to the next with a certain facility, I am not under any illusions about my columns. Locals have raved about some of them, and while I definitely appreciate that and try to always do my best, I know that oftentimes readers are meeting me halfway with their own nostalgic feelings that can be like a warm hug from mama.

I have been criticized by some Fairfield residents because in the "I Grew Up in Fairfield Too" group we do not allow controversy of any kind. Well, except for good-natured controversies like which old-school restaurant made the best hamburger (the correct answer is Dave's, by the way). But

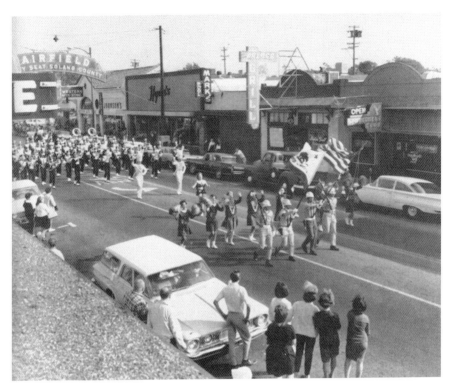

A parade down Texas Street in downtown Fairfield. *1965 Armijo High yearbook.*

modern-day issues like homelessness, crime, economics, politics, religion and the like are absolutely verboten.

I am not wearing rose-colored glasses, much less blinders. I know that Fairfield, California, is not the place it was thirty, forty or fifty years ago. Like any city, it has issues, but there are literally thousands of places on Facebook to discuss or debate those controversial issues. We choose not to do that in the group, instead focusing exclusively on nostalgia.

As it turns out, doing so has benefits far beyond anything I could have imagined. According to a 2008 study, "Nostalgia as a Repository of Social Connectedness: The Role of Attachment-Related Avoidance," researchers from the United States and the United Kingdom concluded that nostalgia can strengthen social connectedness and boost self-esteem, among other positive effects. The findings "indicate that perceived social connectedness—a vital ingredient to optimal psychological functioning and physical health—is deposited in the form of nostalgic memories and is accessed in times of need by retrieving these nostalgic memories. More

generally, the findings locate the psychological significance of nostalgia in its capacity to strengthen social bonds."

This book is a natural progression from my weekly columns and attempts to encapsulate some snapshots of what growing up in Fairfield, California, was like. This is not a history book in the traditional sense, although there is some straight history in it. More accurately, it is a participatory historical experience in which I have often used remembrances of local folks to add flavor. I have also included interludes—based-on-a-true-story fictionalized or sometimes just straight fiction accounts of local events.

While technically I am a baby boomer, I was born in the cut-off year of 1964, so touchstones that many boomers have, like the Kennedy assassination, the Beatles on *The Ed Sullivan Show* and Vietnam, have no real resonance with me. Still, the memories of times and places represented in these pages are probably shared most by baby boomers.

Fairfielders, this book is my gift to you. Well…I mean, you do have to pay for it. Unless you got it from the library. Or someone bought a copy for you. Whatever. Welcome, and thank you for taking this nostalgic plunge with me.

—Tony Wade
March 2021

ACKNOWLEDGEMENTS

I am forever grateful to those who had a part in making this book become a reality. The list includes, but is not limited to, the following: the *Daily Republic*; the Fairfield Civic Center Library; the Solano History Exploration Center; the Vacaville Heritage Council; the "I Grew Up in Fairfield Too" Facebook group; the Armijo Alumni Association; Pam Farmer, for donating items from the Tim Farmer collection; "I Grew Up in Fairfield Too" creator Rick Williams; George Martin; Candace Lightner; Johnny Colla; Nanciann Gregg; Judy Emerson Gosselin; Stanley Emerson; Glen Gaviglio; B. Gale Wilson; Gary Falati; Tom Hannigan; Irving Scible; Lewis and Orville Lambert; Lesa Gonzalez; Cornelis "Cor" Van Diemen; Jayne Nakamura; Kevin S. Tenney; my class of 1942 honorary classmates; the Pizzarino Boys; Darrel Lee Echols; Rick Lowe; Jeff Curtis; my eighth-grade English teacher at Grange Intermediate, Mrs. Jan Edwards; my tenth-grade English teacher at Armijo High, Mr. Alex Scherr; my creative writing teacher at Solano Community College, Ms. Nan Wishner; Susan Peirce Thompson, PhD, of Bright Line Eating; and my History Press editor, Laurie Krill. Super special shout-outs to my immediate family—my brothers Orvis T. Wade Jr., Kelvin Wade and Scott Wade and their spouses, respectively, Patty, Cathi and Michelle, for their love and support over the years, through good times and bad. Thanks also to my wonderful daughter Kaci Wade and my late parents, Orvis T. Wade Sr. and Katy Lou Wade. Also, fist bumps to Don and Lorean Clark and their children, Richard

and Brendyl, who were our family friends in Virginia. We followed them to California and then specifically to Fairfield. Oh, and fist/paw bumps to my Chiweenie Chunky Tiberius Wade, the Jedi Nap Master, for showing me the essential value of power naps.

BACK IN THE DAY

A Flyover History of Fairfield

*I*t's probably best to start with a flyover history of Fairfield that will ultimately land us in the sweet spot that the bulk of this book covers: post World War II to about the mid-1990s.

Fairfield was founded by Captain Robert Waterman. He was born in Hudson, New York, in 1808, and his family moved to Fairfield, Connecticut, after his father was lost at sea on a whaling ship eight years later. He began sailing at twelve and by twenty-one was first mate on a ship.

As a clipper ship captain, Waterman was a speed demon. He helped design the *Sea Witch*, so named because his wife, Cordelia, purportedly once said, "To you she's a wonderful ship, but to me she's just a witch of the sea come to carry you away!"

In 1849, after heading to Hong Kong for tea, the *Sea Witch* reached New York in seventy-four days, setting a record that no sail-powered vessel ever broke.

In 1851, Waterman was skipper of the *Challenge*, which reportedly had a crew of cutthroats and well-known criminals who brought rum, whiskey, knives and guns on board. Waterman, nicknamed "Bully," along with his second mates (who tossed the crew's weapons overboard), were supposedly brutal to the crew—administering beatings and floggings—and they mutinied.

On November 1, 1851, Captain Waterman and his mates were charged with brutal and inhumane treatment of the ship's crew and later stood trial. They were acquitted. There were also charges that during the melee, a ship's mate named Douglass hit a crewman in the head with a belaying pin (used

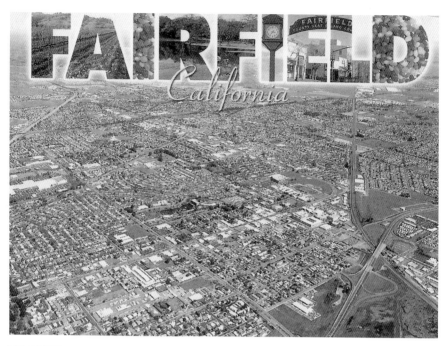

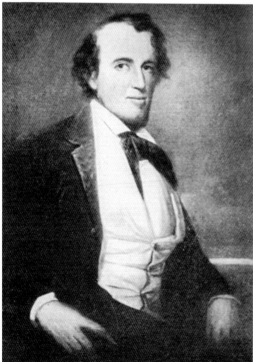

Above: An aerial shot postcard of Fairfield, California. *Solano History Exploration Center.*

Left: Captain Robert Waterman, the founder of Fairfield, California. *Vacaville Heritage Council.*

to secure the rigging), killing him. (Douglass was acquitted.) Yet another ship's mate was charged with kicking a crewman, resulting in his—ouch—emasculation. He was found guilty and fined fifty dollars.

Waterman retired, became a successful landlubbing farmer and, in 1856, settled in California with Cordelia and founded the town of Fairfield. A book called *History of Solano County 1879* by J.P. Munro described in detail how Fairfield became Solano County's seat.

Prior to California statehood in 1850, Solano County was called Benicia County. Vallejo was once the state capital, but that honor was wrested away by Benicia. Then Solano County's seat was Benicia. Finally, like an exasperated/jealous Jan Brady, other Solano County cities cried, "Benicia! Benicia! Benicia!"

The belief that the county seat should be moved to a spot more centrally located caught on, and the fact that it ticked off Benicia-ites was a bonus. Eventually, it was put to a countywide vote.

Representatives from the candidate cities offered incentives to persuade voters. Fairfield founder Waterman pledged sixteen acres for the county buildings plus four other blocks and $10,000. Suisun City's A.P. Jackson, in contrast, offered up $5,500 and a 100-by-120-foot space known as "Owen's Tavern Stand."

Seriously, Suisun? A bar?

In the vote of September 2, 1858, Benicia got stomped. Of 1,730 votes cast, Fairfield received 1,029 and Benicia 625. Rockville received 2 measly votes, so I guess they didn't even offer a bar.

Benicia didn't take the news well. They deduced that Vallejoans who wanted some payback for having the county seat taken from them had thrown their votes Fairfield's way. Benicia's newspaper, the *Solano Herald*, subsequently printed this editorial lament: "In the list of killed and wounded in Wednesday's battle, our eye falls mournfully on the name of Benicia—Benicia! The long-suffering, mortally wounded, if not dead—killed by Vallejo's unsparing hand!" It went on to accuse Vallejo of conspiracy, used the Shakespeare quote "Et tu, Brute?" and threatened vengeance.

Sheesh. What a bunch of drama queens.

By 1873, sentiments had changed, and Vallejo residents thought they had made a major oopsie, because Fairfield was a "dreary, treeless plain" with "meager accommodation for visitors." They even went so far as to say they were ashamed of it.

Modern-day Fairfielders might counter that those observations were made well before we landed the Budweiser and Jelly Belly factories.

A plot to again move the county seat was hatched. I love how the J.P. Munro book describes it: "On the sounding of Vallejo's trumpet, the other towns and cities sniffed the battle from afar, champed their bits and tossed their flowing manes."

Despite champed bits and tossed manes, the effort blew up when, on March 28, 1874, the California State Legislature flatly stated that Fairfield was the county seat.

So there.

GETTIN' EARLY FAIRFIELD ORGANIZED

Fairfield became "duly incorporated as a Municipal Incorporation of the sixth class under the name and style of 'The Town of Fairfield'" after a special election on December 7, 1903. Only 130 people voted—77 for and 53 against.

They chose town trustees whose first order of business was building infrastructure via resolutions and ordinances. Developing streets, sidewalks and a sewer system and delivering electricity and other necessities were priorities. Once those tasks were underway, there was the pesky job of dealing with people and paying for stuff.

Scanned records on the City of Fairfield's website are enlightening.

Multi-hatted marshal: Ordinance No. 5, passed on January 6, 1904, spelled out the duties of the Fairfield town marshal. Besides keeping the peace, he also was a process server, collected funds from various license taxes and was the prosecutor, among other things. His pay was 2.5 percent of all monies he collected.

Fun tax: Ordinance No. 7, passed on January 6, 1904, established a license tax on theaters, concerts, shows and other entertainments where admission was charged. Most licenses had to be paid per quarter, but some were by the day.

Public billiard and pool tables were five dollars per quarter year for each table. Bowling alleys were the same.

I have no idea why theatrical, dramatic or minstrel performances as well as magicians, tightrope walkers and jugglers were three dollars per day, but circus performances, menageries or acrobatics were ten dollars per day. Evidently, lots of thought was put into the decision.

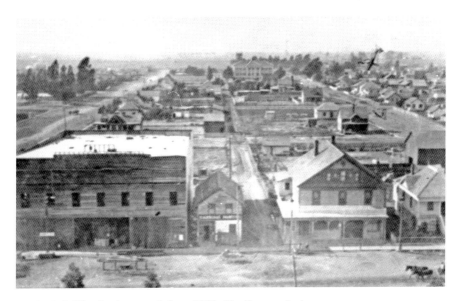

Fairfield, California photograph from 1908. *Tim Farmer collection.*

Animals: Ordinance No. 9, passed on March 9, 1904, prevented cows and other animals from running at large in the town of Fairfield. Ordinance No. 10, also passed on March 10, prevented dogs from running at large without a collar and tags. Canines could run around with the collar and tags, but if they were collarless/tagless and the marshal caught them—yes, it was another of his duties—the owners had only two days to retrieve them and pay. If not—Blam! "Ol' Yeller" time.

Getting around: Ordinance No. 16, passed on August 9, 1905, prohibited the riding of bicycles on Fairfield sidewalks. Ordinance 17, passed the same day, set the speed limit for automobiles in town to "one mile in four minutes." The limit was changed four years later to ten miles per hour.

No booze for you: Section 5 of Ordinance No. 18, passed on September 6, 1905, stated that an adult family member of someone "addicted to the excessive use of intoxicating liquors" could notify drinking establishments in writing not to sell liquor to said relative. If alcohol was sold by a saloon owner within one year of being notified, the town marshal could then haul the owner before the board of trustees, and the owner would have to show cause as to why their license should not be revoked.

Potty mouth: Using vulgar, profane language in the presence or within hearing of women and/or children was a misdemeanor according to Ordinance No. 19, passed on September 6, 1905. Cuss all you want at the fellas.

Dirty dancing: Ordinance No. 51, passed on September 10, 1912, prohibited "indecent, vulgar, improper or immoral dancing." Ragtime dancing was all the rage down U.S. Route 40 in San Francisco, but that foolishness was shut down in Fairfield. The ordinance even named specific dances that were banned. They included the Husking Bee, the Turkey Trot, the Rag, the Texas Tommy, the Grizzly Bear, the Walk Back and the Bunny Hug.

If convicted of the dirty dancing misdemeanor, perpetrators could be fined no less than $10 and no more than $300. In lieu of paying the fine, they could spend between ten days and three months in the hoosegow.

1930s MEMORIES WITH WALTER WRIGHT

Longtime Fairfielder Walter Clyde "Red" Wright Jr. (1918–2011) was famous for his "gravity is a push" theory and ran a museum on Ohio Street. In the early part of the twenty-first century, he looked back on life in Fairfield in the early twentieth century.

"In the thirties, Fairfield had one cop, Howard Yatsie (pronounced yight-see) that everyone just called Howard. He used his own car equipped with a red light and siren that he bolted to the fenders. He always parked his police car in front of the local theater on Texas Street."

Howard would stop speeders and ask them to slow down. He'd take people home who were drunk downtown. Howard was also much more efficient than any DMV when it came to issuing driver's licenses.

"On June 21, 1936, my 18th birthday, I asked Howard for a driver's license. He took a pad from his pocket and wrote one out for me. No test... nothing!"

One domestic disturbance stood out in Wright's mind: "We lived on Missouri Street and one day our neighbor got married and that night they gave the newlyweds a party. The party got a little wild so someone called the cops, which meant Howard. Howard showed up, saw that one of the newlyweds was his cousin and joined the party!"

THE ARMIJO HIGH SCHOOL CLASS OF 1942 REMEMBERS

After not having a class reunion until their fortieth in 1982, the Armijo High School class of 1942 eventually began holding an annual luncheon in Fairfield. They would reminisce about the blissful prewar days and how it all changed overnight on the day—December 7, 1941—that "will live in infamy."

For a number of years, former Suisun City mayor Guido Colla joined three classmates who were also born in 1924, Dorene (Siebe) Darville, Yolanda (Elmo) Messer and Jim Detar (who traveled from Brazil to attend each year).

The class of 1942 lived through historic times in American history. When they started kindergarten, the Great Depression hit. Then, in the middle of their senior year in high school, the Empire of Japan attacked the United States at Pearl Harbor.

"The Friday before Pearl Harbor we left school and on Monday everything had changed. My folks were going to visit relatives in Oakland that Sunday,

The Armijo class of 1942 at a reunion luncheon in Fairfield. *Left to right*: Yolanda (Elmo) Messer, Jim Detar, Dorene (Siebe) Darville and Guido Colla. *Tony Wade*.

so I took the car to the gas station," Colla said. "I turned on the radio and heard the news about the bombing. We left for Oakland shortly afterwards, and by the time we got to the Carquinez Bridge, they already had troops guarding it. I couldn't believe how fast that was."

In Fairfield, as in numerous communities across the nation, neighbors mitigated any potential bombings by mandatory curfews and blackouts at night. "All the street lights were out at night. We had to put up blackout curtains and if block wardens could see a speck of light they'd ticket you," Colla said. "Some cars had louvers on the headlights to make them point down so they could not be seen from above. The block wardens were even nervous about people lighting cigarettes on the street."

"A lot of boys joined the service the next day. You went to school and they were gone," Darville said. "We didn't realize how long the war was going to be. I figured about a year."

Joining the military to fight in the war was a no-brainer for the overwhelming majority of locals. "My boss at Mare Island told me he could get me a deferment and I said 'no.' All my friends were going," Colla said.

"Around here, if you didn't go you were a dirty dog. There were a couple of guys who didn't go and they never lived that down," Detar said.

The class of 1942 took senior photos for Armijo's *La Mezcla* yearbook (http://bit.ly/1942YEARBOOK) in March of that year, but almost a third of the seventy-two students pictured—those of Japanese descent—had been sent to internment camps by May. "When they returned from the camps after the war, Armijo principal James Brownlee [for whom Armijo's football field is named] made sure they got their diplomas and yearbooks," Colla said.

Unlike their male classmates, Elmo and Darville and other females had a different part to play in the war effort. "I remember Dorene's dad telling my dad it was my patriotic duty to go to the USO Club [which used to be located near where the Solano Government Center downtown fountain is now] and dance with the servicemen there," Elmo said. "We went Wednesday and Saturday nights."

"We hated having to go there and dance with those boys, it was such a chore," Darville joked.

2

UP IN THE MORNING AND OUT TO SCHOOL

*O*ver the years, generations of Fairfield children attended local schools and often developed lifelong friendships as well as storing cherished memories of faculty and staff who helped mold them into the adults they later became.

FAIRFIELD GRAMMAR SCHOOL (CORNER OF DELAWARE AND MADISON)

Keith Hayes: Fairfield Grammar School was torn down in the early '50s and replaced by Mark G. Woods School. After it closed as a school it was used by the Sea Scouts, an early Fairfield teen club, the Fairfield Police Boys club, and even the First Baptist Church to name just a few organizations that made use of it. They had two merry-go-rounds: one that went around in a circle and another that would swing back and forth on a pole in the center. Bigger kids would make it hit the pole. They also had big monkey bars and ring swings. It all brings back a flood of memories. Mr. Charles L. Sullivan was one of my favorite teachers. I'm sure I was a pain some of the time. I have my eighth-grade teacher's desk calendar and my name appears on it quite often for after school detention. He whacked me several times when I was a kid...and later hired me when I became a teacher.

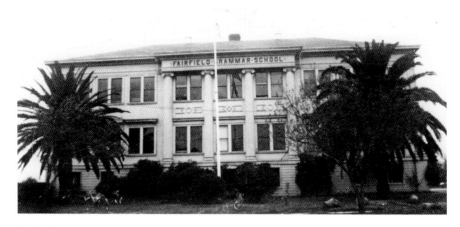

Fairfield Grammar School, which used to be located on the corner of Delaware and Madison Streets. *Solano History Exploration Center.*

Melody Spears: I got kicked out of kindergarten for painting another little girl from head to toe…at her request.

Carol Hanson: My mom and her siblings attended that school. It was about a block away from their home. They lived on Broadway near Delaware. When I went to Mark G. Woods in first grade, the old grammar school playground was where we played. It had the best equipment around— although I did fall off the tall teeter-totter backwards once! I guess I hit my head, which explains a lot.

FAIRFIELD ELEMENTARY (CLAY STREET) (IN 1972, IT BECAME THE ARMIJO HIGH SCHOOL ANNEX)

Pati E. Nelson: I went to Fairfield Elementary for nine years (from kindergarten to eighth grade), graduating in 1961. I remember Mr. Brown, Mrs. Martinelli, Mrs. Fulks and many other fine teachers. Years later I had Mr. Shirley Smith (who later became a Fairfield mayor) as a client in my tax business until he passed away. He was so different as a teacher and principal than as a tax client. It felt strange, at first, to tell Mr. Smith that he couldn't do something.

AMY BLANC ELEMENTARY (KIDDER AVENUE)

Mary Stukey Cader: Mr. Abercrombie! He was a ruler slapper! I remember PE with Mrs. Wilde—what was the game we played called? It was dodgeball, but she called it something else? Oh! Shag ball!

Michele Lynne Morrison: This is making me miss Amy Blanc more every day. Those amazing people took care of my family when I was too sick to. It was more than just a school. We were all a family.

H. GLENN RICHARDSON ELEMENTARY (MEADOWLARK DRIVE)

Eugina Hunter-Barnes: Mr. Richard Sonne was my favorite teacher. I still remember how he allowed us to call him by his first name. During a parent/teacher conference my mother was shocked! Also, we were allowed to play different 45s in class when we got the correct answer on a question.

Christy Thompson: Remember the bunk bed in the classroom?

CLEO GORDON ELEMENTARY (DOVER AVENUE)

Donna Ingram: Cleo Gordon was my third-grade teacher and later became a personal friend. I have a letter she wrote me a few weeks before she died in which she told me she thought of me as the daughter she never had. I grew up poor and had parents who were more interested in partying than

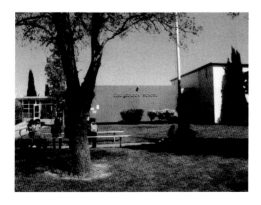

Cleo Gordon Elementary School, named after a beloved Fairfield educator, located on Dover Avenue. *Solano History Exploration Center.*

in being parents. Once we were having a Christmas play for the holidays and every one of the girls wanted to be the Christmas Star. I remember thinking I had no chance, as there were popular girls in my class. Imagine my surprise when Mrs. Gordon chose me! She even brought her own tiara for me to wear, then gave it to me after the show as a Christmas gift!

FAIRVIEW ELEMENTARY (FIRST STREET)

Doris Bruestle: Fairview 63–70. I loved that school. I loved when the church parking lot would ice over and we could run as fast as we could then slide with our tennis shoes like we were skating.

Vicky Valentine Proud: I remember Mr. Broux's Reality Land. We had play money to buy things and pay our bills. We paid rent on our desks and there were fines for breaking class rules. I remember we had elections for mayor and Mr. Broux appointed all the other positions. For the first half of the year, I was the controller; in the second half I got demoted to the garbage man. It was such a learning experience.

Lynn Root: My mom, Pat Henrickson, was a yard duty supervisor and she loved the kids there. My favorite story was a girl came running up to her saying that a boy had said a bad word. When my mom asked what he had said (preparing herself for the worst), the girl said, "He said 'Playtex bra.'" It was so hard for her not to laugh!

Other Fairfield and Suisun City elementary schools included Bransford, E. Ruth Sheldon, Waterman Primary, David Weir, Falls, Dover, Crystal and Crescent.

THE BIRTH OF THE FAIRFIELD-SUISUN UNIFIED SCHOOL DISTRICT

On December 19, 1967, by a four-to-one ratio, Solano County voters approved a plan to combine the area's six school districts into one overarching governing body. On July 1, 1968, the Fairfield-Suisun School District was officially born.

The districts that combined included the Armijo High School District (which also included Fairfield High) and five elementary school districts—Fairfield, Crystal, Falls, Green Valley and Suisun Valley—overseeing twenty schools.

Tom Giugni, who'd become the superintendent of the Armijo High School District in 1967, was tapped for a four-year term as the first superintendent of the newly formed district. Charles L. Sullivan, president of the Fairfield Elementary School District, was chosen as assistant superintendent.

One major structural change the Fairfield-Suisun School District announced in May 1968 was not an easy sell: changing Dover, Union Avenue and Crystal Elementary Schools into intermediate schools for seventh- and eighth-graders. The idea was to aid students' transition from grammar school to high school. Students would have a different teacher for each subject instead of one teacher for all subjects, as in the elementary schools.

Union Avenue Elementary became an intermediate school for the 1968–69 school year and served as a pilot program.

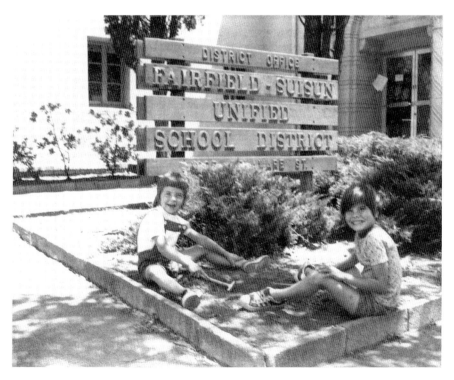

Children play outside the Fairfield-Suisun Unified School District Office, which was located on Delaware Street. *Tim Farmer collection.*

In mid-June, the six separate school districts each had their final board meetings and voted themselves out of existence. The last official act of Fairfield Elementary School District trustees was to rename four schools. An article titled "Want to Name a School?" was published in the newspaper to get suggestions from the public. Until then, schools, for the most part, had been named for locations, and the idea was to honor longtime residents, either living or dead, who'd contributed to education locally. Charles Sullivan accepted suggestions along with reasons for nominating them.

Ironically, the first school name that was changed was Union Avenue Elementary School, to…Charles L. Sullivan (over his objections). Woolner Avenue School was renamed for former teacher E. Ruth Sheldon. Plant No. 15, a nameless new school, was christened H. Glenn Richardson, for a former city councilman, mayor and civic leader active in school activities. Tabor School was renamed for retired teacher Mary Bird.

Charles L. Sullivan developed a school culture and identity and was emulated by later intermediate (or middle) schools, including Dover, Green Valley, Crystal and Grange. Sullivan was closed in 2012, and the campus is now the Sullivan Interagency Youth Center.

More than fifty years after its birth, the Fairfield-Suisun School District governs thirty-two schools, consisting of three high schools, four middle schools, seventeen elementary schools, a preschool, several alternative schools and one adult school. The district is Solano County's largest school district and its third-largest employer.

GREEN VALLEY INTERMEDIATE (RITCHIE ROAD)

The Green Valley School District was established in 1854. In its first year, the one-room schoolhouse served thirty-eight children ranging in ages from four to seventeen.

The building, located on Ritchie Road in Cordelia, was later fashioned into a two-room structure with a belfry and a huge American flag for first to eighth grades. By 1888, attendance had swelled to ninety-one children, many of whom kept the horses they rode to school in a stable behind the building.

In the mid-1920s, the school was given a facelift featuring an arched entrance. When the school was expanded in 1947, it was given a more nondescript, boxlike exterior.

Green Valley Union Elementary School became Green Valley Intermediate School in 1968 as part of a restructuring. The first Vikings yearbook, for the 1969–70 school year, was dedicated to Principal Ernest Mohr, who was praised for his "endless foresight, boundless enthusiasm and eternal smile."

The earlier Green Valley schoolhouse caught fire and burned in 2003. The later, boxier Green Valley building, despite efforts by locals to save it, was later demolished as well. A new Green Valley Middle School was built in 2004 on Gold Hill Road.

Cheryl Tate: In 1970–71, we rode the bus from Fairfield down the back roads to Green Valley. You stepped off the bus every morning to the smell of cinnamon rolls in the cafeteria and Principal Ernest Mohr greeting students with a smile.

Debbie Wink-Murphy: I loved Cecil Robinson, the band director. We were practicing marching and I had to step in cow crap. He praised me for keeping my stride. Yuck.

Jennifer Jones: I started kindergarten there in September 1959. Our moms car-pooled us from Green Valley. I-80 was Highway 40 back then. There were no overpasses, and crossing the highway was mighty scary. Somehow we all survived the crossings while seated in massive seatbelt-less cars.

Sharon Berdell: I was in kindergarten, the year was 1963 and I can still remember the day Mr. Golomb pulled our teacher, Mrs. Duvall, out of class. When they returned she was crying. President Kennedy had been shot and we were sent home.

CHARLES L. SULLIVAN INTERMEDIATE (UNION AVENUE)

Sullivan students experienced a contrast of two days in June.

On Thursday, June 5, 1969, Charles L. Sullivan Intermediate had its first graduation ceremony, honoring 305 students in Veterans Memorial Park. The graduation also served as an official dedication of the school, located on Union Avenue. The Sullivan band played, and Charles L. Sullivan himself gave an address before presenting the diplomas.

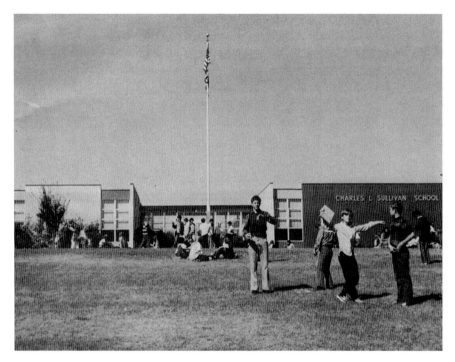

Charles L. Sullivan Middle School, which was located on Union Avenue. *1974 Sullivan yearbook.*

On Thursday, June 7, 2012, Charles L. Sullivan Middle School closed its doors for the last time. The school board had voted five to two to mothball it due to a $6.5 million budget deficit.

Former Sullivan Celtics shared memories of their times there.

Robin Edwards: I was one of the reasons they stopped doing skating for PE (sorry, folks). I fell, and someone tried to use my arm as a ramp and failed. That was the second time in my life I had a broken arm—the first was the same way when I was in second grade. The nurse told me that at least one student every year broke a bone.

Jackie Letterman Covey: One time during band practice, I was slouching. Mrs. Ruff came behind my chair and kicked me in the butt. Thanks to Mrs. Ruff, I have great posture and never had back problems!

Holly Gregory: In my seventh-grade year, I had Mrs. Ruff for band. I remember her beating her hand rhythmically on the backs of the chairs of

students who just couldn't stay on tempo. She was a tough old bird, but a fabulous teacher. The band program there was excellent.

Wanda Yates: I attended that school as a kindergartner when it was Union Avenue School and then again as a seventh- and eighth-grader when it was Sullivan. I attended David Weir first through sixth (it closed), Sullivan seventh and eighth (it closed). Do you think they're gonna close Fairfield High?

GRANGE INTERMEDIATE (BLOSSOM AVENUE)

The grand-opening ceremonies for the $1.8 million, twenty-acre Grange Intermediate School (now Grange Middle School) on Blossom Avenue took place on November 10, 1974.

The school's name, chosen by a citizen's naming committee, honored the nation's oldest agricultural organization, the National Fraternal Association of Farmers, and the Tabor Avenue Grange Hall (later Lynne's Dance Studio and now a church).

The first seventh- and eighth-grade classes totaled about 550 students. They chose Grizzlies as the school mascot and gold, black and white as the school colors.

Then-librarian and later principal (as well as a Solano County Office of Education trustee) Mayrene Bates expanded Grange's library exponentially after winning an $82,000 grant. She also ingratiated herself into the hearts of many locals by selling Marvel comic books at lunchtime.

Former Grange Grizzly staff and students shared memories.

Teacher Jan Edwards: I had never taught middle school before so it was an eye-opener. When school first opened, it wasn't quite ready, so we split sessions at Crystal. I remember it being a time of great excitement. I felt very flattered to be among such dedicated colleagues. Debbie Sorenson was a real driving force who was organized and enthusiastic. I remember Barbara Johnston, who used to put her feet up on her desk and read her newspaper and I swear she could see through it to what her kids were doing. The kids were all so fun, challenging and energetic. I remember them with great affection.

Tracy Vest: I was there the third year the school was open, so we lacked pretty much everything in the amenity department. I remember for PE

having to get on a bus and ride over to the skating rink in the winter and the Fairfield Plunge for swimming in the spring.

Steven LeBlanc: Mine was the first student picture on Mr. Gaut's Science Hall of Fame posted on his classroom's wall. I remember him giving me extra stuff to do because I loved science, so I ended up with 1,049 points out of 400.

Helen Cat: I remember the electric fence running from Sunset Avenue to the back of the school. I didn't know it was electrified until I made the mistake of touching it!

Carl Lamera: Best middle school snack bar ever! It introduced me to It's It, the ice-cream delicacy. I also learned that one can live on cinnamon rolls and French bread with melted butter.

Dave Gabeler: We played in a field for football and played at other schools for basketball because the gym wasn't built yet. I had a blast there and met lifelong friends along the way.

ARMIJO HIGH SCHOOL
(UNION AVENUE/WASHINGTON STREET)

Before officially moving to its sprawling, city-blocks-long campus on Washington Street in 1960, Armijo High School taught generations of Fairfielders on a campus located on Union Avenue.

The school was named after an early Mexican settler in Solano County, Jose Francisco Armijo. The very first building used for instruction under that name was a single classroom in the Suisun Elementary School building in 1891 that had thirty students. In 1893, a separate Victorian Queen Anne–style wooden building with an elegant bell tower, carpenter Gothic decorations and fish-scale shingles was built on the eastern end of Union Avenue. The year also boasted the first graduating class from Armijo High School.

On March 14, 1915, a majestic new sixteen-thousand-square-foot reinforced concrete building with a price tag of $85,000 was dedicated as the new Armijo High School. For forty-five years, that tri-story building served as the Solano County seat's high school. As the population of Fairfield grew, a newer facility was needed and was ultimately constructed on Washington

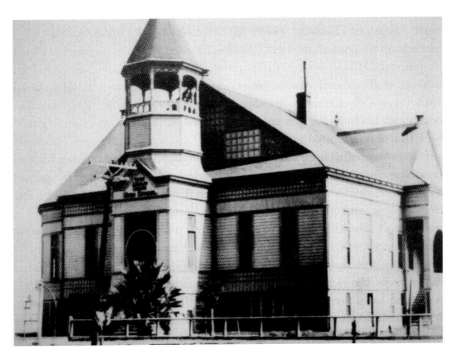

The original Queen Anne–style Armijo High School building, erected in 1893. *Armijo Alumni Association.*

The then-new 1915 Armijo High School building, which replaced the original Queen Anne building. *Solano History Exploration Center.*

Street. Students began attending classes there in the 1960–61 school year, and the old Union Avenue building was vacant for nearly a decade.

On October 20, 1970, the old Armijo High School structure was reborn as the Solano County Hall of Justice after a $1.4 million makeover.

Local Armijo grads remembered the old school.

Donna Scholl Cooley, class of 1960: It was a great building—what I thought a high school should look like. The rooms were all big with lots of room. I loved climbing the marble stairs. It just had character and I hated to leave that building.

Eleanor Lozano Cullum, class of 1952: My husband, Lyle Cullum, and I attended Armijo High in the old building from 1949 to 1952. My husband played many basketball games in the old gym and also took auto mechanics and shop in the back buildings across the street from the tennis courts. The building was three stories. The girl's gym was on the ground floor with the classrooms and the cafeteria (which served delicious home-cooked food). All the lockers were on the second floor as well as classrooms and the principal's office. The auditorium had a lovely stage, and the acoustics were great! I participated in several plays there. The class of 1952 graduated on that stage, and our class had 79 graduates! There was also a tennis court in front of the gym, and most of the guys could hit the tennis balls across the street over to the jail.

Gene Thacker, class of 1957: We moved to Fairfield in 1953, and the signpost said the population then was 3,318 people. Back then if you said you were from Fairfield, people would ask "Is that anywhere near Suisun?" One funny thing I remember was me and three friends were going to do a talent show and pantomime the Four Deuces' "White Port Lemon Juice" in the Armijo Auditorium. Somebody had to drop out, so we couldn't do it. The show's director, I think it was Mr. Briggs, told us if we were not in the show we couldn't watch rehearsal, and he threw us out. So we just went to the next set of doors and were sitting in the balcony watching. He spotted us and kicked us out again. Then we went upstairs, and the doors going into the auditorium balcony had the hinges on the outside, so we took the hinges and the door off and were watching. He saw us and kicked us out again. Then there was the ceiling where the floodlights would come out and shine on the stage. So the practice is going on and Briggs looks up and sees three heads sticking out of those holes. We got in trouble.

Right: Texas Street at Washington facing east; the new Armijo building would be on the left. *Tim Farmer collection.*

Below: The majestic view headed north down Union Avenue. The old Armijo High is on the right, the old courthouse is dead ahead. *Solano History Exploration Center.*

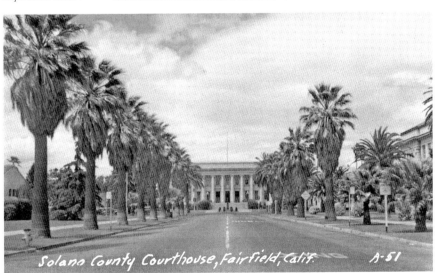

Nanciann Gregg, class of 1959: We moved here from Ohio and I didn't know that building was where I would be going to school when we first came in off of the old Highway 40. It was a very beautiful walk from Suisun to Armijo walking down Union Avenue. Seeing the sun rising and the palm trees lining the street and the courthouse at the end—then getting closer and seeing the library and school with its pillars and walking up those steps. I think that intersection is still the most majestic in Fairfield.

ARMIJO HIGH SCHOOL HISTORY TIMELINE (NOT ALL-INCLUSIVE)

1891 Armijo Union High School opens and meets upstairs in Suisun Grammar School. The curriculum includes Latin, English, history and mathematics.

1893 A wooden Queen Anne–style structure located on Union Avenue in Fairfield becomes the first Armijo High School building. The first graduating class, in this year, consists of three students.

1915 The new Armijo school (and now the Solano County Hall of Justice) is erected, a sixteen-thousand-square-foot reinforced concrete building echoing the neoclassical style of the courthouse across the street.

1928 Minnie Meyer, class of 1928, breaks the women's world record in the 100-meter dash: 12.03 seconds.

1929 A devastating fire in the library causes extensive damage to the school.

1932 Class of 1917 grad Ernest Crowley, who was blinded in a duck-hunting accident as a boy, is elected to the California Assembly, where he serves until his death in 1952.

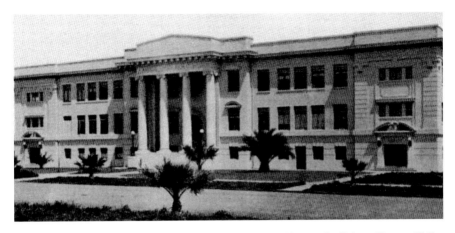

The then-new Armijo building, which opened in 1915 and is now the Solano County Hall of Justice. *Armijo Alumni Association.*

1945 Coach Ed Hopkins, class of 1933, later a legendary Armijo coach, as a member of the U.S. Navy witnesses the Japanese surrender, ending World War II.

1953 Mike Diaz, class of 1953, sets state basketball records for points in a game, points in a season and points in a career, all of which remain city records.

1955 Armijo's football field is dedicated to James Brownlee, the school's longest-tenured principal (1921–49).

1956 Teacher Ivan Collier starts Armijo's Cadet Corps, predecessor of the Air Force ROTC program.

1960 The new Armijo building opens on Washington Street.

1964 Armijo vice-principal Sam Tracas becomes the first principal of the new Fairfield High School.

1968–78 Ray Lindsey directs the Armijo Band, which becomes the Armijo Superband.

1972 Fairfield Elementary School becomes the Armijo Annex (Wings E-H).

Left: The logo of the Armijo Superband, which was a caricature of famed band composer John Philip Sousa. *1979 Armijo High yearbook.*

Right: Former Fairfield mayors and lifelong friends Tom Hannigan (*left*) and Gary Falati. *Gary Falati.*

1972 The gymnasium is dedicated to class of 1959 grad and Armijo teacher/coach E. Gary Vaughn, who died that same year.

1974 Class of 1958 grad Gary Falati is elected to the Fairfield City Council, where he serves sixteen years as mayor.

1975 Michael Burgher, class of 1975, sets a state record for wrestling wins with sixty-six.

1980 Armijo class of 1964 grad Candace Lightner founds Mothers against Drunk Driving after her daughter is killed by a drunken driver.

1980 Phillip Glashoff, class of 1969, teaches himself to turn scrap metal into colorful, whimsical art that is now admired around the world.

1981 The annual Bowen Lectures, still held each fall at the University of Berkeley, begins in honor of internationally known mathematician and class of 1964 grad Robert Edward "Rufus" Bowen, who died in 1978.

1982 Doug Martin, 1976 grad who was drafted by the Minnesota Vikings, is selected to the NFL Pro Bowl.

1983 Huey Lewis and the News, featuring saxophonist/class of 1969–70 grad Johnny Colla, releases the multiplatinum album *Sports*.

1984 Class of 1949 grad Nori "Pat" Morita is nominated for a Best Supporting Actor Oscar for his role as Mr. Miyagi in *The Karate Kid*.

1987 Class of 1970 grad George Martin makes a pivotal sack on Denver Broncos quarterback John Elway, helping his team, the New York Giants, win Super Bowl XXI.

1991 The Armijo Alumni Association is formed after the school's centennial celebration.

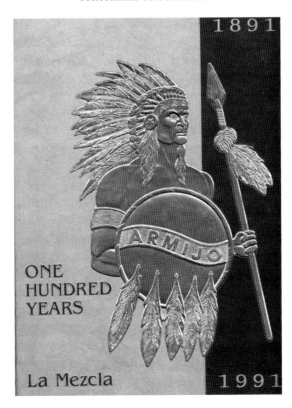

The embossed cover of the 1991 Armijo High School *La Mezcla* yearbook commemorating the school's one-hundredth anniversary. *Armijo Alumni Association.*

1991 Class of 1979 grad Jim Inglebright participates in his first NASCAR race.

1992 Ramona Garrett, class of 1970, becomes the first woman and the first African American appointed to serve as a Solano County judge.

1993 Class of 1983 grad Steve DeVries achieves the number-eighteen rank in the world for doubles tennis.

1993 Greg "Huck" Flener, class of 1987, plays his first Major League Baseball game, pitching for the Toronto Blue Jays.

1994 Class of 1983 grad Jim Bowie gets called up by the Oakland A's.

2000 Former Fairfield city councilman Garry T. Ichikawa, class of 1965, is appointed a Solano County Superior Court judge.

2007 Twenty-one-year-old Matt Garcia, class of 2004, becomes the youngest Fairfield City Council member ever elected.

2009 President Barack Obama nominates class of 1964 grad Robert Hale as undersecretary of defense (comptroller).

2011 Armijo's new $4 million library is unveiled.

2014 Armijo's new administration building opens.

2015 The Armijo Alumni Association launches the Armijo High School Hall of Fame honoring outstanding alumni, faculty and staff.

2016 The Armijo Alumni Association celebrates Armijo's quasquicentennial (125th anniversary) with a fundraising concert called "Armijo Rocks," featuring 1960s classmates/band the Malibus.

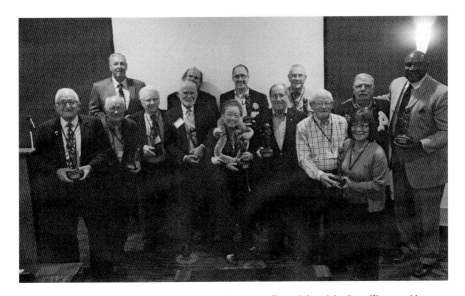

Armijo High School Hall of Fame inductees in 2015. *Front, left to right*: Sam Tracas, Alex Scherr, Guido Colla, Darrell Anderson, Rebecca Lum, Gary Falati, Ron Cortese, Eileen Butt (for Doug Butt). *Back, left to right*: Jay Dahl, Phillip Glashoff, Raymond Courtemanche (for Matt Garcia), Ray Lindsey, Rae Lanpheir, George Martin. *Not pictured*: Johnny Colla. *Yumi Wilson Photography*.

2017 Sheila Smith becomes Armijo's first female principal.

2019 Armijo retires the Indian mascot, which was adopted in 1929, and becomes the Armijo Royals.

THE ORIGINAL FAIRFIELD HIGH SCHOOL WELCOMES CROSSTOWN RIVAL FAIRFIELD HIGH SCHOOL

Armijo High School's roots go back to 1891. For decades, it was the only high school in Fairfield. In the 1950s and the 1960s, however, a population boom fueled in part by Travis Air Force Base, the creation of Interstate 80 and the attraction of Fairfield's advantageous geographic location accelerated the need for a second high school.

Fairfield High School was originally part of the Armijo Joint Union High School District, and the first principal, Sam Tracas, had been an Armijo vice-principal. The 1964 Armijo yearbook contained a greeting/friendly challenge for the new school: "We encourage them to compete

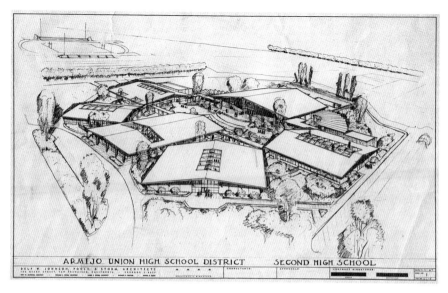

The architect's drawing of Fairfield High School (originally part of the Armijo Union High School District). *Armijo Alumni Association.*

with us in a race for excellence in scholarship, citizenship, athletics and other worthwhile activities."

Fairfield High broke ground in 1963 and started receiving some students in 1964. Since construction was still taking place, students took part of their classes at the new school and were bused to Armijo for others.

Student Shar Richardson-Smalarz hated going to Armijo in the mornings, because her friends went in the afternoons. For others, though, it worked.

Carol Dillon Potter: My family lived across the street, behind what is now Kmart, which back then was an empty field. I was lucky enough to go to Armijo in the morning and Fairfield in the afternoon and walk home from there.

Fairfield needed a mascot, school song and more to develop their own culture. Some locals, who back then were eighth-graders who would be incoming freshman the next year, recall being allowed to choose those things. Others remember it as not being quite so democratic.

Jim Parks: I remember being bused over to the campus with the other eighth-graders. We were to vote on the school colors, mascot and other things. What I also remember was that these things were already decided,

but they let us feel like we were the ones who chose. We were told that the colors would probably be red and white, because they were the cheapest, but to go ahead and vote anyway.

Soon after the school was established, crosstown rivalry pranks began in earnest.

Marianne Israel Jennings: We put chicken manure on the Armijo campus. They hung a live chicken from our gym. A classmate rescued him and he became our mascot!

On June 7, 1968, members of the first senior class of Fairfield High received their diplomas in the quad, with Kay Jenkins given the honor of being the very first Falcon to graduate.

Generations of Fairfield graduates have now made their mark on the world by becoming productive citizens. Among their ranks are a Pulitzer Prize winner, a Super Bowl champion and an Olympic gold medalist.

FAIRFIELD HIGH SCHOOL HISTORY TIMELINE (NOT ALL-INCLUSIVE)

1963 Fairfield High breaks ground. The original name considered was Solano High School.

1964 The first school year begins, and students split classes between the new school and Armijo.

1965 Student representatives from ten local elementary schools choose the school colors (red, white and black), motto (*Factum non dictum*—Latin for "deeds, not words") and mascot (the falcon).

1965 The Concert Band—later the Scarlet Brigade—is founded under director Richard Grokenberger.

1966 The Fairfield High School yearbook, *The Talon*, debuts.

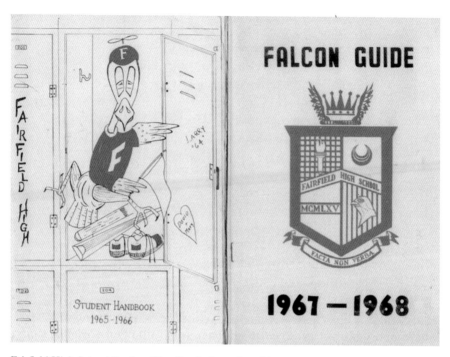

Fairfield High School Student Handbooks from the mid- to late 1960s. *Jim Osada.*

1966 Jay Dahl, class of 1970, plays his first varsity basketball game as a freshman. He plays varsity all four years. In his junior and senior years, Fairfield wins the Delta League championship. Dahl still holds the school record for career rebounds (892).

1968 The iconic red letter "F" is installed in the quad.

1968 The first Falcons graduated on June 7, 1968.

1978 Softball coach Ron Clarke starts a thirty-three-year career at Fairfield High, amassing a 732-266-5 record. He is the winningest coach in any sport in city history—by more than 100 wins.

1980 The Scarlet Brigade marches in the Tournament of Roses Parade for the first time.

1980 Catherine McKenzie, class of 1976, graduates from the U.S. Air Force Academy, part of the first class to include women.

1986 Schaefer Stadium, named after the first Fairfield High School Boosters Club president, Bob Schaefer, opens.

1987 *Witchboard*, a film written/directed by the class of 1973's Kevin Tenney, has its nationwide debut.

1989 Mike Dailey begins coaching Fairfield's track team, leading it to six Sac-Joaquin Section titles. He also coaches two boys' cross-country teams to league titles (1992, 1993).

1992 Fairfield is selected the Monticello Empire League's School of the Year for Athletic Excellence.

1995 Carlyn Rojas, class of 1995, batted over .800 during the 1995 Sac-Joaquin Section Division I softball playoffs, leading the Falcons to the second of their four all-time division championships.

1996 Class of 1988 identical twins Nelson and Wayne Braxton release their debut smooth-jazz album *Steppin' Out* as the Braxton Brothers.

1998 The gymnasium is dedicated as the Ronald D. Thompson Gymnasium, honoring basketball coach Ron Thompson. In twenty-six seasons, Thompson won eight league championships and acquired a 409-262 record.

2000 Al Pimentel, Fairfield varsity baseball head coach for more than thirty years, retires as athletic director. Pimentel also coached basketball and football. His football highlights include coaching an undefeated freshman team.

2001 Angelo Rodriguez, Fairfield High English teacher for twenty-one years who tragically drowned in 1986 while saving two children, is honored as the namesake of the city's newest high school.

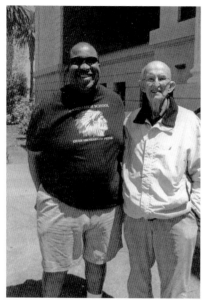

Left: The author, Tony Wade, with Armijo alumnus and legendary Fairfield High basketball coach Ron Thompson in 2015 at Thompson's sixty-fifth reunion. *Ed Lippstreu.*

Below: Carpino Quad at Fairfield High School with the iconic red *F* in the middle. *Tony Wade.*

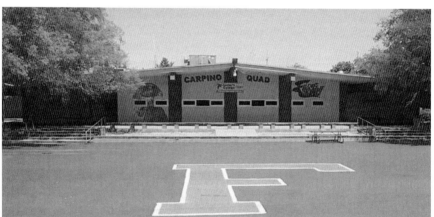

2006 On May 6, 2006, the Fairfield High School administration building is dedicated to the school's first principal, Sam Tracas.

2006 Class of 2002 softball pitcher Alicia Hollowell helps the Arizona Wildcats win the Women's College World Series. Hollowell, who earned the MVP Award all four years of her high school career, holds the Fairfield High School records for strikeouts in a season and in a career.

2006 Quinton Ganther, class of 2002, is drafted by the Tennessee Titans in the seventh round of the 2006 NFL Draft.

2008 The quad is rebranded as Carpino Quad, honoring thirty-eight-year teacher Clyde "Mr. Fairfield High" Carpino.

2009 Catherine Moy, class of 1979, becomes the first Falcon to serve on the Fairfield City Council.

2011 Desmond Bishop, class of 2002, recovers a crucial fumble in Super Bowl XLV, helping the Green Bay Packers clinch a victory over the Pittsburgh Steelers.

2012 Tracy K. Smith, class of 1990, wins a Pulitzer Prize for her book of poetry, *Life on Mars*.

2012 Keshia Baker Kirtz, class of 2006, wins a gold medal for the United States as part of the 4x400 relay team at the Summer Olympics in London.

2013 Erin Hannigan, class of 1982, is elected to the Solano County Board of Supervisors, representing the First District.

2013 John Campbell, class of 1975, is appointed by President Barack Obama as the thirty-fourth vice chief of staff of the U.S. Army.

2015 Dan "Bam Bam" Stell, class of 1982, four-time kickboxing champion (as well as a referee, trainer and promoter), becomes a ninth-degree black belt professor in Kajukenbo.

2015 The Fairfield High Athletic Hall of Fame is revived after memorabilia was lost in a library remodel in the 1990s. As of 2017, the total number of standout Falcon athletes inducted is seventy-six.

3

WHAT DO YOU DO FOR FUN AROUND HERE?

*F*rom playing with pollywogs in local creeks to riding bikes all over town and participating in neighborhood baseball or football games, Fairfielders have always found ways to have fun. Other diversions included sliding down Woodard Hill on cardboard, blasting off for outer space in the rocket ship slide at West Texas Street/Allan Witt Park, swimming, skating, bowling and more.

DITCHES, POLLYWOGS AND FROGS—OH MY!

Debra Merritt Bruflat: Maybe other antiques like me remember when the ditch that ran along Lee Bell Park wasn't paved over. I'm thinking it was around 1962–65. It was the most *awesome* place to play and catch tadpoles! I lived on Jefferson Street. There was also a ditch behind my house next to the prune factory. It was full of licorice-smelling weeds six feet tall to hide in. I once took a bunch of tadpoles home in a jar and put them in a fishbowl. I came home one day to find they had all grown legs and jumped out!

Lisa Anglin: The neighborhood kids and my brother and I could always be found playing in the ditch behind Dover Park. We used to catch minnows and tadpoles there. We used to get in trouble for playing there. Our parents didn't like that they couldn't see us during the ball games. My mom got desperate and started carrying a bicycle horn to use for calling us to come.

Lynn Markle Jewell: I used to slide on cardboard down the side of the ditch near Lee Bell Park.

Andy Cooper: Ditches were a favorite place to play! They were everywhere it seemed! The one at Lee Bell Park was right across the street from our first house. Then there was a huge one behind our house on Clay Street. It separated the house behind us and ours. But my favorite ditches were out past Dover Terrace off the Air Base Parkway where we fished for bluegill. There was a guy that had a pet raccoon and I would bring live bluegills home from the ditch and we would flood the circle around the big tree in the guy's front yard and put the fish in it. He would bring out the raccoon and hook him to a chain and let him "fish" for his food. That raccoon was so happy when it saw me! I'm sure he knew I was bringing him the fish.

ROCKET SHIP SLIDE

Gabriel Warren: I never thought I'd lay eyes on this again! I literally have dreams that I'm in that thing again. Was always so nervous about going up to the top level.

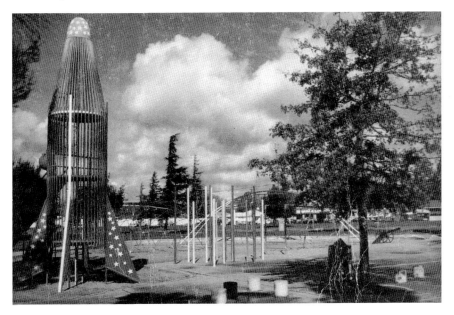

The rocket-ship slide at Allan Witt Park from the cover of the 1979 Fairfield-Suisun phone book. *Solano Genealogical Society.*

Joe Edwards: I went to the moon a few times there!

Patty Rae: We didn't let the little kids in the top of the rocket, it was ours.

Kevin M. Thorpe: Back when kids were tough. All-steel playground equipment. Shorts plus shiny steel slide that you could fry an egg on.

SOLANO DRIVE-IN/CHIEF AUTO MOVIES

In 1950, Fairfield got its own drive-in theater, the Solano Drive-In (later Chief Auto Movies). The July 14 grand opening offered a double feature of *Young Daniel Boone* and the Bowery Boys comedy *The Lucky Losers*. Admission was sixty-five cents for adults and twenty cents for children. Kids younger than ten got in free.

Solano Drive-In boasted a forty-two-by-sixty-one-foot screen, believed to be the largest west of the Mississippi. It had a state-of-the-art sound and projection system, a children's' playground, a fully stocked snack bar and at the grand opening even offered an enticement for post–World War II moms: free baby bottle warming.

Over the years, the theater showed a wide variety of films to Fairfielders. They ran the gamut from a cinema classic by legendary Japanese filmmaker Akira Kurosawa (*Rashomon*), to a film set in Fairfield but not filmed in Fairfield by Fairfield director Kevin Tenney (*Witchboard*), to a popcorn thriller double feature (*Orca the Killer Whale* paired with *Godzilla vs. the Cosmic Monster*).

Sneaking into drive-ins by hiding in the trunk of a car evidently was a nationwide phenomenon, and Fairfield was no exception. Many recall cramming so many people inside trunks that exiting them resembled a clown car. Some people were actually disappointed when the drive-in started charging by the carload instead of per person.

On December 14, 1988, a fierce windstorm with sixty-seven-mile-per-hour gusts tore down the Chief Auto Movies' screen. While it would be poetic if true, 'tis but a (sub)urban legend that the last film to play there was *Gone with the Wind*.

Locals shared remembrances on Facebook.

Tara Gray: I was able to see the screen from my bedroom window. I was so upset when it blew down.

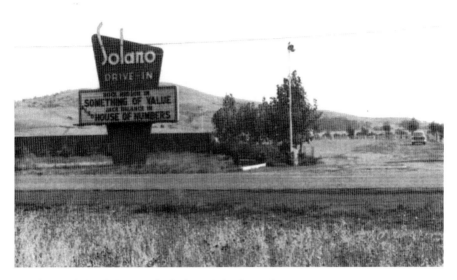

The Solano Drive-In Theater in the late 1950s. *Donna Covey.*

Jack Munoz: My first daughter was conceived there.

Cary Blasingame: That windy December night in 1988 I was working swing shift at the Sheriff's Department and was held over for grave shift because of the storm. I spent the first few hours doing traffic control while downed trees were cleared on Suisun Valley Road near Twin Sisters then drove in to Fairfield at 3:00 a.m. I was stopped at the light on Travis Boulevard and North Texas Street and saw a two-foot-by-two-foot chunk of a panel from the drive-in screen. I drove up North Texas and saw that the screen was gone.

Skating (M&M Skateway, Redman's Roller Rink/Skateland)

Suisun City had a skating rink that opened in 1948 called the M&M Skateway. It featured an 8,500-square-foot maple-wood floor. It was a long warehouse building with double doors on one end that were sometimes

opened to let in the pleasant Suisun breeze. Skaters recall in the 1950s not only sometimes hearing water slap against the pylons it was built on but also seeing the slough through missing slats.

Soon, it was also the go-to local place for dancing to live music, first big bands and later rock 'n' roll. Artists who headlined included Bobby Freeman, Fats Domino and Roy Orbison.

The name of the M&M Skateway was changed to the Pioneer Skateway in the early 1960s. In 1966, it was dubbed the Pioneer Ballroom and staged a few notable rock concerts featuring, among others, Love with Arthur Lee, the Sir Douglas Quintet and a then relatively unknown San Francisco group called the Grateful Dead.

In 1968, the building was condemned, razed and burned.

Redman's Roller Rink, owned by Earl and Edith Redman, was established in 1963 at 2250 North Texas Street. According to former Fairfield resident Terry Lanham, Earl Redman introduced a major innovation by allowing skateboarders to bring their "sidewalk surfing" indoors into the rink. Another thing Lanham remembers is seeing bands playing there, including the Golliwogs, who later became Creedence Clearwater Revival.

Now Suisun City's rink had had dances and brought in some relatively big names, but in June 1964, Redman's Roller Rink featured a one-night-only evening with an international superstar, jazz legend Louis Armstrong. While he had been a household name for decades by that time, Armstrong's popularity was peaking, as just the month before, his recording of "Hello, Dolly!"—which would later win a Grammy—had knocked the Beatles out of the number one spot on the charts.

For $2.50 each, approximately 500 Fairfielders saw Armstrong perform nearly thirty songs, including "Birth of the Blues," "When the Saints Go Marching In" and "Mack the Knife," among others. "Hello, Dolly!" brought the house down, and he performed three encores.

In attendance at the show was an eleven-year-old Suisun City resident who played clarinet in the Crystal Elementary School band, Johnny Colla, who later became a saxophonist/guitarist/songwriter with Huey Lewis and the News. Colla's mother, Rosie, brought him and his friend Allan Cornett to the show.

"At the end of the show I wanted autographs. I went to the men's room and grabbed some paper towels," Colla said. "The band's dressing room was the skate repairman's room. We opened the door and it was full of smoke and there was a pint bottle sitting there and a couple of old dudes with their shirts off and they were sweaty. Whoever answered the door was gruff and

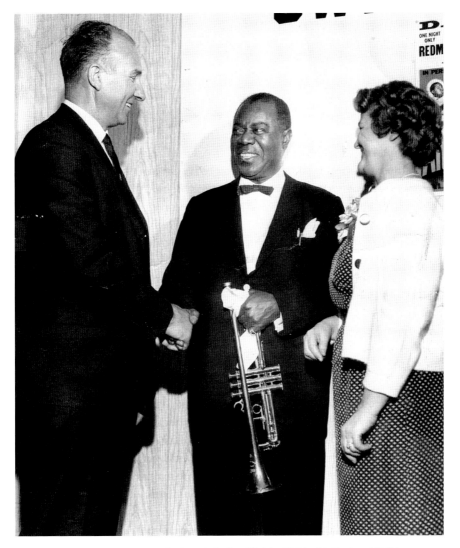

Jazz legend Louis Armstrong at Redman's Roller Rink in 1964 with Earl and Edith Redman. *Patricia Redman Johannes.*

it started to close. Louis Armstrong, bless his heart, said, 'Oh, hell, Joe! Let him in and sign the boy's autograph!'"

Colla and Cornett not only received autographs of most of the band (Colla later wrote down the instruments of the respective band members next to their names), but Armstrong also gave them his handkerchief. The two preteens talked it out, and it was decided that Cornett would keep the handkerchief and Colla would keep the autographs.

More than fifty years later, Colla has kept the memory of seeing and meeting a jazz legend who performed live in Fairfield. He also kept the autographed paper towel. "I keep it tucked away in a 'Pictorial History of Jazz' next to the picture of Louis Armstrong," Colla said.

In the 1970s, Redman's became Fairfield Roller Rink and then Skateland Roller Rink. Wayne Purdy was the general manager for years before buying the place himself. He was a certified professional skater and, according to numerous frequent customers, brought professionalism to Fairfield. Competitors who won events would have their picture posted on a wall in all their finery.

In addition to the rink being a place for recreation on the weekends, many middle schoolers from both Grange Intermediate and Sullivan Middle Schools remember going there for PE.

Former resident Michelle McNeice Cummings was a "rink rat" whose whole family loved skating. Her mother, Estelle McNeice, was Purdy's best friend and co-manager. Cummings's grandparents were even the janitors there for a time.

One fond remembrance was of the Gold Skate Classic.

"It was an annual weeklong competition held in Bakersfield with skaters from all over California," Cummings said. "We performed huge themed production numbers which we'd practice in Fairfield as a show. The first one I remember was 'Sesame Street.' My sister was Ernie. We had music, costumes—the whole nine yards. It was like Ice Capades on skates."

Skating is not only fun — it's homework

870 Sullivan students find unique physical education class terrific exercise

By TONY BRUNELLI
Daily Republic Staff Writer

FAIRFIELD — For 870 students from Charles L. Sullivan Intermediate School, skating everyday was not only fun, it was homework.

Physical education classes from Sullivan made the short trek to Fairfield's Skateland every day for the last three weeks as part of their PE program — but a lot of work went into the 55-minute sessions.

Each student was taught the basic skills of skating, then was taught a routine which he or she had to memorize and perform at the end of the three weeks for a

grade, instructor Sylvia Marchi said.

It was not strictly a fun-type program, she said, there was work to be learned.

Started as an activity for rainy weather, this program has been going on for 12 years now as students are quickly walked the one-mile round trip to the rink.

Marchi said the brisk walking keeps the students' cardiovascular system in top shape as does the skating. The whole process — the round-trip walking and time to put on the skates — takes only 15 minutes.

The cost is one reason the school keeps up the program.

With no costs for travel, Skate-

land charges $800 for the three-week session for all the students, six classes of them. The less than $1-per-student expense, which includes the skate rental, comes out of the school budget, Marchi said.

The skating also is excellent as a carryover sport for students for lifetime activities and things they can do with their families, she said.

Many of her students have told her that the skating sparked afterschool skating pleasure and some have even gone on to perform in skating competitions.

Wayne Purdy, manager and head professional at Skateland, was very pleased the school could afford to use his rink for one of its

P.E. classes.

"Those who didn't know how learn got a chance at a low cost," Purdy said. "It also gave those who never have been inside a chance to see what kind of fun have."

Marchi, who is one of five teachers for the class, said there was no discipline problems throughout the three weeks and the program was good for socializing morale.

The other teachers involved were Sandi Nygard, Steve McCl[?], Garreth Bogar and Steve Tayl[?].

Currently, students are learning tumbling, gymnastics, aerobics, basketball and modern dance their physical education class Marchi said.

A Daily Republic *newspaper article on local students using skating as PE.* Fairfield Civic Center Library microfilm.

Gail King spent considerable time at Skateland in the late 1970s. While moves she learned in lessons were important, so was fashion, and King rocked the requisite silk roller derby windbreaker set off by then-popular skin-tight Dittos jeans in a rainbow of colors.

Joe Joyce claims he and his friends "ruled" the rink from 1975 to 1979. "Funny how we complain about our kids wasting all their time on video games today when we spent thousands of hours skating around in a circle on a small wooden floor," Joyce said. "The best part of Skateland was the friends. I met my wife there. We dated until she graduated from Fairfield High and got married four days later. We have children and grandchildren now."

Cupid worked overtime at Skateland. While many locals remember the year they met their spouses, Alan Thomas Hirschenhofer II actually remembers the *time*. "On December 22, 1982, I saw this lady skating who looked dead-on like Pat Benatar," he said. "At about 8:43 p.m., I saw a commotion by the snack bar. I had a look, and beheld my future bride beating the living hell out of some poor schmuck."

Hirschenhofer stopped her right before she delivered the coup de grâce to the guy's face, and Wayne Purdy played couples only. While they skated together, Hirschenhofer told his pugilistic Pat Benatar lookalike, Jo Ann Stow, that she would marry him and give him four sons. She later did just that, and they are still married today.

Evidently, sometimes love is *not* a battlefield.

Purdy sold the rink in 2001, and it later became the Trading Post, a used furniture store.

The Fairfield Plunge

JoAnn Curley, thirteen at the time, christened the $120,000 Fairfield Plunge swimming pool at its dedication on May 30, 1958, by being the first to dive in. Curley earned that honor by winning a naming contest run by the city. She was also awarded free admission for one year.

Curley was the official first swimmer, but a few weeks earlier, five Fairfield youths unofficially went in the pool and were busted swimming there before the grand opening.

Residents have long tried to beat the Fairfield summer heat in pools, at Lakes Berryessa and Solano and anywhere else they could find cool water. Some people shared their memories.

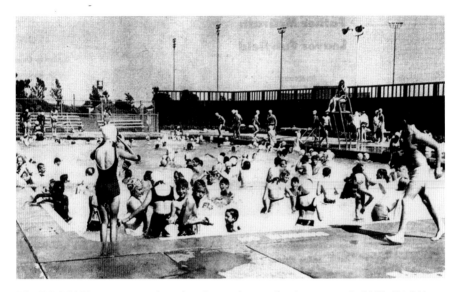

The Fairfield Plunge community swimming pool opens for the summer in 1969. *Fairfield Civic Center Library microfilm.*

Dale Poncy: We used to sneak into the Armijo pool at night. We got away with it until we decided to start jumping off of the high dive—it was easy to see us while driving down Texas Street.

Gary Falati: The old Fairfield Plunge was the cheapest babysitting service at the time in the city. For a child to be able to stay alone at the Plunge, they had to demonstrate they could swim across the pool without any assistance. Parents quickly figured out that by enrolling their child in a two-week swim class, the child could learn how to swim across the pool. We changed the policy to reflect a minimum age for admittance without an adult.

Keith Hayes: Around 1950–51, the nearest public swimming pool was in Vacaville and had just a thin wall separating the boys' and girls' dressing areas. Over the years, boys had tried to carve peepholes through the wall. One day, one of the boys found a peephole and decided to look through it. When he started to peek, one of the girls blew face powder into the hole. It took about twenty minutes before he could see out of that eye. One Peeping Tom cured.

WHEN FAIRFIELD WAS A MOVIE HOUSE MECCA

In July 1921, the theater in downtown Fairfield opened on the corner of Jackson and North Texas Streets. The first movie locals chuckled at was Charlie Chaplin's *The Kid*.

Later dubbed Solano Theatre, the movie house was completely remodeled in 1945 and reopened to much local fanfare. In the pre-Fandango.com 1950s, a printed schedule of what was playing for the month was delivered to each household in Fairfield.

In 1974, the theater changed from Solano Theatre to Fairfield Cinema I. Across the street was Fairfield Cinema II (which, unlike the original, did not have a balcony called the smoking loge).

Local residents recalled their moviegoing days.

Judy Leetham: In the 1940s, it cost twenty-five cents to get in. It was five cents for popcorn, candy or drinks. Serials every Saturday would end at an exciting part, leaving us in suspense until the next Saturday. They had onstage talent shows and raffles. My big brother won a girls' bicycle and gave it to me!

Fairfield Cinema I, which was formerly the Solano Theatre, in the mid-1970s. *Solano History Exploration Center.*

The Fairfield Cinema II, located across the street in downtown Fairfield from the Fairfield Cinema I. *1985 Armijo High yearbook.*

Andy Cooper: In 1966, I was twelve and went to the movies almost every weekend. One Friday night, after the newsreel and cartoons had played, I asked the girl at the snack bar what the name of the movie was. Her reply? *Khartoum.* "No, the movie," I said. "What's the name of the movie?" Again she replied *Khartoum.* I said, "Not the cartoon, the movie!" That's when she explained that *Khartoum* was the name of the movie! I was embarrassed enough to remember it to this day!

Trish Jacobs Greene: The first movie I ever watched there was *Jaws* when I was five. I don't know what possessed my parents to take me to that movie at that age! People were jumping and spilling their popcorn and sodas all over the place every time that shark showed up on the screen!

In 1970, the twin theaters on North Texas Street called the Americana opened and later became known for all-night horror movies, midnight rock 'n' roll flicks and even later, cheap movies.

Victor R. Hopkins Jr.: All-night horror movies at the Americana Theater; Vincent Price and Boris Karloff. Love those guys! I used to bring a blanket for me and my date to cover up. What happens in the Americana stays in the Americana!

In October 1979, the Chief multiplex, near Chief Auto Movies, opened. It featured…wait for it…three theaters. Five years later, however, Solano Cinema 6 opened near Solano Mall, doubling the number of screens.

David Lew: Solano Cinema 6 was my second home when I was a kid. I went to all the huge midnight showings there. Actually went to see the midnight showing of *Terminator 2*, but every show was sold out, so we opted for the 2:00 a.m. showing!

Robert Arms: I was five years old when it opened. My mom took me to see *Jungle Book*. Before the movie they had door prizes, and I won a full-on Hot Wheels race track set. Going to the movies for the first time was like one of the greatest moments of my childhood!

LOCAL LIVE BANDS

Much like a family tree, Solano County's local bands spread roots and branches far and wide. Groups from the 1960s, '70s and '80s that grew out of local garages and school music programs formed a musical fraternity that continues to entertain locals today.

Darrell Lee Echols Sr. is the founder and drummer for arguably the biggest local band in Solano County and beyond, the Time Bandits. He got the musician bug following two older brothers who played guitar and tenor saxophone in Fairfield's Natural Soul Band from 1969 to 1971.

"There were a lot of rock bands around then, like Yewess Army and Arm and Hammer, but in Fairfield they were the premier soul band," Echols said. "It was like going to watch the James Brown show. They had a big horn section and dance steps like right from the Apollo Theater."

The Natural Soul Band played songs by artists ranging from Isaac Hayes and the Bar-Kays to early Blood, Sweat & Tears. They played high school dances and the Battle of the Bands at the Dan Foley cultural center in Vallejo.

While his brothers were laying down the funk, Echols was just a "snot-nosed kid." But in 1970, he joined the Fairfield High Scarlet Brigade Jazz Band and made connections with other local musicians. They included future members of some of the most popular and well-known local groups, like CP Krunt, Rosewood and Laser Boy, as well as individuals who would achieve national and international success.

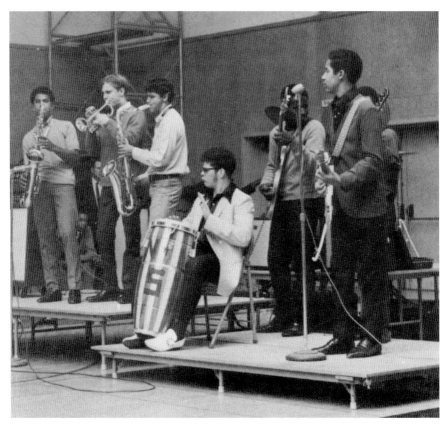

Local Fairfield group the Natural Soul Band performing at a rally in the Armijo High School gym. *1969 Armijo High yearbook.*

"There was a community of musicians in Fairfield and every weekend we'd be jamming at someone's house or garage or farm and make connections," Echols said. "I used to have jam sessions with friends Mark Bates and Herman Wilson and every weekend someone would knock on Mark's garage door to jam. Before he got really famous with Huey Lewis, Johnny Colla knocked on that door. Another time it was Paul 'Maceo' Harrell, the original sax player for Con Funk Shun, who were called Project Soul then. It was really cool."

Echols's first band was called Hog Wild. It featured a few of the guys who later became Laser Boy as well as Peter Ricks, the lead singer of the Natural Soul Band, which had broken up by that time.

Back in the '70s, bands performed at West Texas Street (now Allan Witt) Park. Other popular places included the Grange Hall (later Lynne's Dance Studio and now a church) on East Tabor Avenue and several clubs,

including the NCO Club on Travis Air Force Base, the Sundown Lounge and the 21 Club.

One special place was called "Hippie Hill." Located off Rockville Road right past where it is bisected by Suisun Valley Road, the hill became "the spot" in the '70s to hear local live bands perform. "Hippie Hill looked like something from San Francisco in the late '60s," Echols said. "It was a real melting pot and there were no hang-ups about race or anything. It was just really mellow and peaceful."

Echols's musical journey went from the second incarnation of the Natural Soul Band called the 7th Movement Band to an outfit called Mixed Breed, and then to a funk band named Evolutions. He then joined the military.

Echols sat in with the USO band during his thirteen years in uniform, and when he returned to Fairfield, he joined a group called Major Minor with Phil Greene of CP Krunt and Rick Whedbee, a fellow FHS grad.

The Time Bandits came about because of the connections Echols had made two decades before with locals Whedbee, Robert Koehn and Rick Lowe. At first they played what Echols called self-gratifying blues, but when they noticed no horn bands were around, they added trumpet player Roy Word III, who had played in the Natural Soul Band.

Jeff Curtis, a talented guitarist and keyboardist who was an alumnus of both CP Krunt and Laser Boy and who was a friend from Echols's high school jazz band days, also joined.

"Even back when I was on active duty and would come home on leave I would go see Laser Boy or CP Krunt and I used to say that when I got out of the military, I was going to get in a band with Rick Lowe and Jeff Curtis," Echols said. "We keep connecting, everything connects."

THE MALIBUS

Dana Byerley, who graduated from Armijo High in 1966, was the bass player for one of the first popular garage bands in Fairfield, the Malibus. They began in 1963 and included rhythm guitarist Scott Lockwood, lead guitarist Rick Lowe (formerly of Laser Boy and now a Time Bandit) and drummer Dean McMillen.

"We started out with surf music like 'Walk Don't Run' and 'Little Deuce Coupe,' and as music changed worldwide we changed with it," Byerley said. "We got into folk rock like 'Mr. Tambourine Man' and, of course, did 'Louie Louie' as it was the party song of that decade."

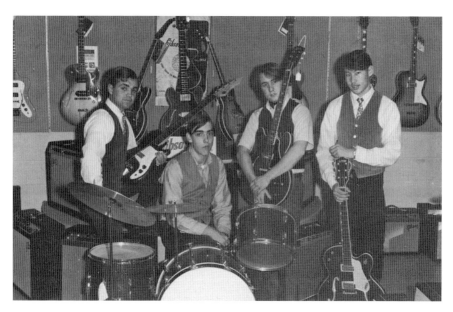

Fairfield band the Malibus in 1966. *Left to right*: bassist Dana Byerley, drummer Dean McMillen, guitarist Scott Lockwood and lead guitarist Rick Lowe. *1966 Armijo High yearbook.*

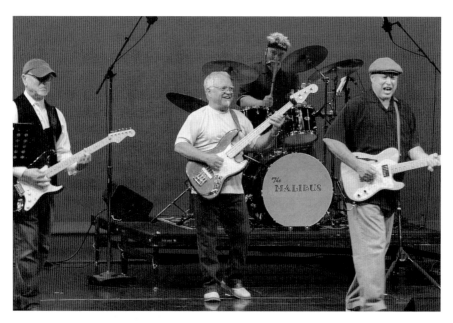

The Malibus regrouped to perform at the 2016 Armijo Alumni Association fundraiser "Armijo Rocks!" *Yumi Wilson Photography.*

Wearing either their matching royal blue vests or then-popular madras shirts, the Malibus played everywhere. "We played all the sock hops, Armijo, Vacaville, and Rio Vista high schools and all the elementary schools," Byerley said. "We played at Redman's Roller Rink on Friday and Saturday, where everybody went to dance and fight and have drag races and everything else we did in the '60s."

The group played until 1968, when Byerley moved away. In 2016, the band came together to headline the Armijo Alumni Association's 125th anniversary extravaganza called "Armijo Rocks" at Fairfield's Downtown Theatre.

CP KRUNT

Former 1970s–80s Fairfield-based rock 'n' roll band CP Krunt never made it big but enjoyed regional success. Some of the band members have now gone on to the "great gig in the sky," but memories of the talented group remain.

CP Krunt grew out of friendships between Armijo High musicians Bill Mason (drums), Greg Adams (guitar, vocals), Kent Harvey (organ, flute, vocals) and Glade Rasmussen (bass), who were all in the school band. Later lineups included Jeff Curtis, Phil Greene, John McIntyre, Steve Ring and Michael Monasterio.

"At Armijo there was marching band, concert band and jazz band. We thought it'd be fun to have a rock band, too," Glade Rasmussen said.

Before becoming a member, guitarist Phil Greene went up against CP Krunt in rival groups at West Texas Street Park (now Allan Witt Park) Battle of the Bands competitions—and always lost. Since he couldn't beat them, he joined them when Kent Harvey left.

"We did a mixture of rock and soul and originals. We'd play Earth, Wind & Fire's 'Shining Star' or the Ohio Players' 'Skin Tight' and then follow it with Peter Frampton's 'Show Me the Way' and Stones and Beatles songs," Greene said.

Other memories Greene recalled was the band being coached on vocals by legendary local opera singer Connie Lisec.

They played for thousands of people at Sacramento's Cal Expo, but hometown shows were special. "Gigs at the Fairfield or Vacaville community centers were great because there were so many people squeezed in and we'd have a light show and flash pots and dry ice, and Greg and I would jump off the speakers at the same time like Mark Farner of Grand Funk," Greene said. "We felt like stars."

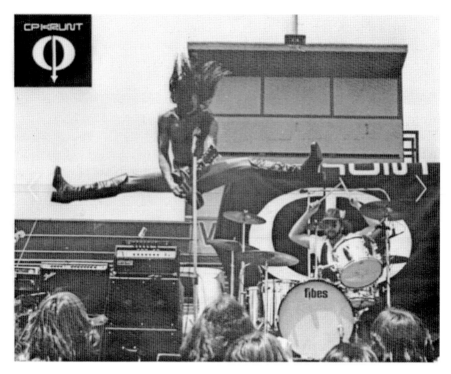

Fairfield rock band CP Krunt performing at Armijo High School. *Kathleen Adams McIntyre.*

Around 1980 or 1981, they'd play at a Sacramento club called Slick Willie's, and some kids would ride their Stingray bikes there to sit outside and listen to them play. Those kids later became the band Tesla.

LASER BOY

Laser Boy, designed to be a local supergroup of sorts, comprised musicians from popular groups like Runnin' Strut (guitarist Rick Lowe, keyboardist Chris Holmes and drummer Paul Ojeda), Rosewood (bassist/vocalist Ron Kimball) and CP Krunt (keyboardist/guitarist/vocalist Jeff Curtis).

"We could play anything—disco was happening then so we did Bee Gees stuff, but we also played Journey, Motown tunes and complicated Kansas and Yes songs that lasted like nine minutes. We even experimented with some Lenny White and Pat Metheny. All that plus our original tunes," Lowe said.

Laser Boy built up a loyal local following, playing everywhere from Fairfield Landing to the Sundown Lounge. They also opened for groups like the Knack and Huey Lewis and the News (featuring Lowe's old Cottonmouth bandmate Johnny Colla) when they came to the Bay Area.

In the early 1980s, Laser Boy made a video for their song "Give Me One More Shot," which aired on MTV. The show it premiered on was called *Basement Tapes*. The show was a contest for aspiring bands, who would send in a video to go head-to-head against others as viewers called in to vote for the one they liked best. The winning band got a professionally produced video and a major-label recording contract.

Unfortunately, Fairfield didn't have MTV at the time. The only place to get it for years was on the big screen at the pizzeria in Scandia Family Fun Center.

Laser Boy didn't win, and the band broke up in 1985.

"Being in a band is kind of like a marriage. If it's not succeeding it kind of turns sour," Jeff Curtis said. "It's not that the people aren't good people or that they aren't good musicians; it just kind of runs its course. I feel so blessed for being able to play with such good friends."

Fairfield Landing Restaurant, where Laser Boy and numerous other local bands frequently played. *1985 Armijo High yearbook.*

I LOVE IT WHEN WE'RE CRUISING TOGETHER

I go out cruisin', but I've no place to go and all night to get there
—*Styx, "Too Much Time on My Hands"*

George Lucas's classic 1973 film *American Graffiti* explores cruising in 1962 Modesto, and the plot and subplots of the movie were reflected in the real-life downtown drama that took place every weekend in cities all over America—including Fairfield.

During the local cruise's heyday in the 1950s,'60s,'70s and '80s, restless, hormone-drenched teens from Fairfield and surrounding areas poured into downtown every weekend. Young folks would drive up and down the Fairfield "strip" looking for something to do, some trouble to get into or a weekend romance.

There is trouble that is just a nuisance, and then there is the kind that started to happen nearly every weekend in downtown Fairfield. The Fairfield City Council considered a cruising ban in January 1984 but tabled it to get public input. In December 1984 and January 1985, there were two stabbing incidents, and that was all she wrote.

Tuesday, May 21, 1985, is "The Day the Cruising Died" in Fairfield. That day, the Fairfield City Council unanimously passed an ordinance that banned repetitive driving between designated checkpoints.

Perhaps it is more accurate to say that 1985 was the day that cruising *started* to die. When the city council banned downtown cruising, it had the effect of pushing it—and the resultant problems—onto North and West Texas Streets. In April 1991, a total of 435 calls were made for police assistance in an eleven-block area on North Texas Street.

Also, fully 60 percent of people charged with crimes in that area were from out of town. Since several other cities had already outlawed cruising—most notably Modesto—Fairfield became a magnet for eager cruisers.

On June 4, 1991, the Fairfield City Council, in a unanimous decision, voted

One of the signs that was erected in Fairfield when the cruising ban went into effect. *Tony Wade.*

to expand the 1985 ordinance that banned downtown cruising to include everywhere from Beck Avenue to Marigold Drive.

The ordinance was an emergency measure and took effect immediately. Signs were erected on West Texas Street announcing that cruising was prohibited from 6:00 p.m. to 3:00 a.m. and listing the boundaries and relevant penal code section. They are still there today.

Locals who know that the first and second rules of "The Cruise" are that you don't talk about "The Cruise" shared their memories nonetheless.

Frank Cain: My nephew and I used to sit on the hood of my black-and-white '57 Chevy in a parking lot near Dave's Hamburgers. I never saw the sense of wasting gas when most everyone would cruise by sooner or later. I thought we should all just meet in the Wonder World parking lot and save our gas for Berryessa trips.

Eric Rahn: They outlawed the cruise right when I got my license. Thanks, Fairfield!

Linda Ueki Absher: My best friend managed to talk her older brother into letting us borrow his car—a sixties-era, red VW bug. For some reason, my friend's mother wouldn't let us take off unless we took their dog, Trixie (a cocker spaniel) with us. Since it was late fall, I also took my prized ski jacket. We jumped in the car, throwing Trixie and my jacket in the back seat, and took off. We cruised North Texas a few times, making several U-turns to circle back, but like our past cruises, we failed to meet our objective: to meet boys. We finally gave up and started for home, but not before I decided to reach for my jacket, since it was getting cold. That's when I realized that Trixie had quietly ralphed all over my prized possession. We ended the evening with me hosing off my jacket in my best friend's front yard.

Mitchell Walker: On October 3, 1983, I went downtown and my friends Otis, Roy, Dennis and Tony were in our regular spot. My future wife, Nicola, was sitting in the back of Dennis's truck. Two months later, we had our first date at an Alabama concert. By February 1984, we were engaged, and on April 6, 1985, we were married and have been ever since. We have three great kids. Had it not been for the cruise I would not have met my wife or built the wonderful life we have together.

Karl Offermann: I wish my kids could cruise…and get out of my house!

Christine Bandy McAfee: I met my husband on the cruise in 1983. Parachute pants, leather vest, followed by a kegger party—too much for a young girl to resist!

Allen Wheeler: I remember some friends and I were hanging out by Fairfield Cinema I, trying to get a carful of girls that we knew to pull over. We got the driver's attention; she looked back and ran her daddy's car into a parked car on the street. I miss that kind of fun!

Teresa Roberts Washburn: I remember my parents driving me down the cruise when I was thirteen to let me know I would never be doing that!

Claudine Beyers Fowler: I remember just getting my license and my dad told me not to leave town. So my friend and I stayed in Fairfield and cruised. I got home and my dad asked where I went last night. He had checked the mileage. He figured I had to have gone out of town because I put fifty miles on the car. I wasn't allowed to drive next weekend. It wasn't until sometime later that he saw the news about cruising and realized I was telling the truth.

Ray Ann Fune Sullivan: I put 80,000 miles on my first car just cruising Texas Street in the '60s.

Teri Langdon Harper: In 1983, my friend and I almost hit two airmen in a convertible. They yelled at me and then we spent the rest of the night passing each other on the cruise. We met up at McDonald's and talked. The next night, one of them came into Dave's Hamburgers, where we worked, to ask my friend out for a date. She was too shy to talk to him so we started talking and he asked me out instead. We went out the next night and six weeks later we got married. It's been over thirty years now.

4

FAMOUS FAIRFIELDERS AND FAMOUS FAIRFIELD VISITORS

What constitutes fame? On some level, it is subjective. If you visit the Fairfield, California Wikipedia page, it lists numerous notable people—some household names and some not. Those highlighted here are just a representative sample of those who have achieved notoriety beyond Solano County's seat. It is not an all-inclusive list.

NORIYUKI "PAT" MORITA: ARNOLD ON *HAPPY DAYS* AND MR. MIYAGI IN *THE KARATE KID*

Pat Morita achieved fame in the 1960s as a standup comedian and then in the 1970s and '80s for playing Matsuo "Arnold" Takahashi, owner of a diner on the hit TV show *Happy Days*. Morita is probably best known for playing Mr. Miyagi in the 1984 motion picture *The Karate Kid*—a role for which he was nominated for a Best Supporting Actor Oscar.

What some may not know is that Pat Morita was also a 1949 graduate of Armijo High School.

Morita was born in Isleton to Japanese immigrants Tamaru and Momoye Morita on June 28, 1932. His birth name was Noriyuki, or "Nori" for short. As a small child, Morita contracted spinal tuberculosis and was in a full-body cast for approximately seven years. At about age eleven, he underwent a then-experimental procedure that changed his life dramatically.

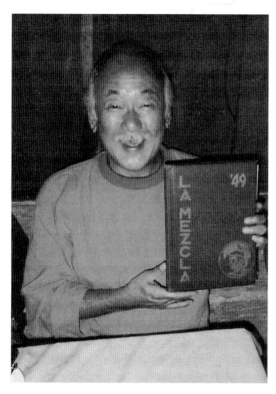

Left: Armijo class of 1949 grad and star of the film *The Karate Kid*, Noriyuki "Pat" Morita, holding the 1949 yearbook at Mankas Corner. *Art Engell.*

Below: Armijo class of 1949 grads (*left to right*) Ernie Moretti, Art Engell, Pat Morita, Ed Lippstreu and Doug Machado. *Art Engell.*

Unfortunately, that time was right after the Japanese attack on Pearl Harbor. American citizens of Japanese descent were summarily rounded up and sent to relocation camps for the duration of the war. "One day I was an invalid," Morita said in a 1989 interview with the Associated Press. "The next day I was public enemy No. 1, being escorted to an internment camp by an FBI agent wearing a piece."

Karen Herman, director of the Archive of American Television, conducted an intensive interview with Morita in 2000, which is available for viewing on the organization's website, http://www.emmytvlegends.org. In it, Morita described the feeling he got when the war ended and he went to Armijo High. While some parents of classmates harbored lingering anti-Japanese sentiments, Morita didn't experience that from his peers.

"When I became a teenager and went to high school, these young kids didn't carry that kind of baggage with them," Morita said. "I was just Nori and a classmate and they gave me a sense of self for the first time in my life."

Morita's account was borne out by some of his classmates, including longtime Fairfield businessman Art Engell. "When he came to our school he was just another guy and everybody liked him. He was funny as all get out," Engell said. "He was involved in everything, drama, you name it—he was even on the basketball team even though he was only 5-foot-2—but he only got in when we were 100 points ahead."

Aside from the comedic performing-arts talents for which he later became famous, Morita was an artist and drew a mural of a miner panning for gold. It was used on the inside front and back covers of the 1949 Armijo *La Mezcla* yearbook.

Ron Thompson, who later became a legendary coach at Fairfield High School, graduated from Armijo a year after Morita and Engell. "Nori was a sports nut and wanted to be an athlete so bad, but he was very small and just wasn't very athletic,"

Thompson said, "When I was a freshman and the Japanese students came back, four of his buddies came out and we won the baseball championship, but poor Nori just didn't measure up and I know that was very disappointing for him."

Morita began going by the name Pat after high school. According to the Emmy legends interview, a Catholic priest who he'd befriended once jokingly told him, "If I ever convert you, your name will be Patrick Aloysius Ignatius Xavier Noriyuki Morita."

After achieving fame, Morita still found time to help out his old classmates. "Art Engell and some other guys started a bank and they had Nori come for

the grand opening," Thompson said. "I was in the coach's office at Fairfield High and here comes Art Engell bringing Nori in to see me. That's when he was on *Happy Days* and the kids were going crazy."

Morita was coaxed by Engell to attend the class of 1949's ten-year reunion, which was the only one he made. For the fiftieth reunion in 1999, Morita sent a two-and-a-half-minute video for his classmates titled, "A Message from the Last of the Great Prospectors." In it, he dressed as a forty-niner panning for gold in Alaska and turned celebrity name-dropping on its head by mentioning the names of several of his classmates, including Engell, whom he referred to as "gems."

Morita died in 2005. In the Archive of American Television interview, he was asked how he would like to be remembered. "I guess I'd like to be remembered for having touched a lot of lives in happy, positive ways," Morita said.

JOHNNY COLLA: HEART AND SOUL

Huey Lewis and the News are household names, having sold more than thirty million albums worldwide. The first household for Johnny Colla, the band's saxophonist, rhythm guitarist, singer and songwriter since its inception in 1979, was in Suisun City.

Colla, born in 1952, played clarinet at Crystal Elementary School and learned piano at home. He commandeered older brother Dino's record collection and also soaked up influences from his uncle, who introduced him to 1940s and 1950s country music, and a cousin, who hipped him to soul.

As a freshman at Armijo High School in 1965, Colla met Robert Koehn, and the two became fast friends. Koehn played guitar and Colla obtained a bass, and with two other members they formed the Furlanders, Colla's first band. "We were just pulling songs off the radio like the Rolling Stones' 'Heart of Stone' and the Young Rascals' 'Good Lovin'," Colla said. "Robert Koehn, my best friend, running buddy and guitar player extraordinaire, was working on 'Sleep Walk,' but I don't think we ever tackled it."

All that survives of the Furlanders are pink business cards they had printed.

Cary Schultz, a neighbor of Koehn's, was in a band called the Curbstones, whose members were a little older. They wore Beatles boots, and Colla still wonders where in Fairfield they obtained them. When the Furlanders and the Curbstones broke up, the Yewess Army was born.

"Cary liked the blues and we were writing original songs and playing pretty heady stuff for sophomores in high school," Colla said. "Then I discovered Sons of Champlin, and eventually I got the idea to add a horn section. I got these two locals, Andres Abarra and Lach Loud, and I'd say that was the beginning of the end for the Yewess Army, because Cary didn't like the direction."

Besides rock bands, Colla played in school bands, and under Armijo Super Band director Ray Lindsey he blossomed. Lindsey gave Colla the chance to switch from clarinet to oboe, which got him out of the all-girl clarinet section. He also introduced him to another instrument. "Ray Lindsey put a sax in my hand for the first time," Colla said. "He gave me [Sousa's] 'The Washington Post' and I learned it in four days."

At Vallejo Junior College (now Solano Community College), Colla met musicians from around the county and was enthralled by bands such as Vallejo's Arm and Hammer. He eventually joined Cottonmouth.

Huey Lewis and the News 1986 publicity photo. *Left to right*: Chris Hayes, Johnny Colla, Huey Lewis, Sean Hopper, Bill Gibson and Mario Cipollina. *Johnny Colla*.

"Cottonmouth had been together for a while and had a wonderfully eclectic song list," Colla said. "Ricky Lowe [later in Laser Boy and Time Bandits] and I would play lines together. I'd play alto sax, and he'd cover the second part with his guitar."

After Cottonmouth, Colla joined Sound Hole and played with them for four years, but it all came crashing down in 1976. "Me and keyboard player John Farey were unceremoniously fired at Bozo's Bus Stop in Fairfield after playing to a packed house. I was crushed because I felt we had something unique," Colla said.

Fortunately, they both fell upward, later recording the album *Heard Ya Missed Me, Well I'm Back* with Sly and the Family Stone. Afterward, Colla's musical career involved playing with numerous groups, including Rubicon (whose members later formed Night Ranger) and eventually hooking up with Huey Lewis. The rest, as they say, is history.

Colla realized he'd "made it" when he was driving his green 1968 Camaro and heard "Do You Believe in Love" on KFRC. "I had to pull over, crank it up, and the hair stood up on my arms," Colla said.

Huey Lewis and the News' career highlights include selling nearly ten million copies of their number-one album *Sports*, having nineteen top-ten singles and being nominated for an Academy Award for Best Original Song for "The Power of Love" from the 1985 film *Back to the Future*.

A personal highlight for Colla was being a part of the recording of the biggest single of the 1980s, "We Are the World." The benefit tune, penned by Michael Jackson and Lionel Ritchie, featured a who's who of the music world including Stevie Wonder, Paul Simon, Dionne Warwick, Willie Nelson, Kenny Rogers, Tina Turner, Diana Ross, Ray Charles, Bruce Springsteen, Bette Midler, Jeffrey Osborne, the Pointer Sisters, Sheila E., Smokey Robinson and many more.

"Truth be told I think the News (like the Jacksons and the Pointer Sisters) were merely wallpaper—more faces, voices and bodies to fill out the riser for the group shot and backing vocals," Colla said. "But that didn't bother me. I was in the presence of many of my musical heroes past and present, and was honored to be a part of pop music history."

Locals shared memories of Johnny Colla:

Renee Calvez: Growing up in the '80s, my best friend and I were huge Huey Lewis and the News fans. All the kids in our neighborhood (in Suisun by the marina) said that Johnny Colla lived in the house around the corner so we went and knocked on the door. Mrs. Colla answered and told us that

The Grateful Dead's Bob Weir and Jerry Garcia with Huey Lewis and Johnny Colla performing at the 1988 Bay Area Music Awards in San Francisco. *Jay Blakesberg.*

Johnny didn't live there anymore, but showed us a gold album that hung in their hallway. We thought we were so cool after that!

Donni Ann Nusbaum Quinlan: His mom Mrs. Colla was my fifth and sixth grade teacher and his brother Dino does my hair! Great family!

Linda Smalley Hoffman: I just knew him as one of the guys in the neighborhood. He always made me laugh—it was years before I knew of his success. It makes me smile to think someone so kind did so well.

George Martin: Gentle Giant

What do you get when you add influential, motivating mentors and a bright young man gifted with natural athletic abilities and a desire to succeed? You get George Martin, Super Bowl champion.

Martin's family relocated to Fairfield in the early 1960s from South Carolina, where his father was a sharecropper. Martin had never played football or any other sport when he began attending Dover Elementary

School as a seventh-grader. "I was a complete novice, but could catch the ball really well. They started calling me 'Sticky Fingers'," Martin said.

Street football and pickup games of basketball helped, but proper coaching did wonders. "I vividly remember when I first went out for organized sports at Armijo High School. Gary Vaughn, for whom the gym is named, molded my raw talent and developed me into a precision athlete on the basketball court," Martin said. "Bob Miller and Bill Fuller did likewise in the football arena."

"The high school mentor who had the most impact on me was Coach Ed Hopkins. He took me under his wing and almost treated me like a son," Martin said. "We'd have in-depth discussions on how I could have an impact on society. That's when I ran for student body president, won and was voted an Outstanding Teenager of America. That showed me I could make contributions not only on the field of play, but also, more importantly, on the field of life."

In Martin's first game for the purple and gold, he scored two touchdowns—one of which was a surprise. "We were playing Galt and I was a wide receiver. I ran a pattern, caught the ball and got hit by two guys. I was disoriented and thought I'd screwed up. My teammates ran up, congratulating me. I had no idea I'd caught the ball in the end zone," Martin said.

Basketball was Martin's first love, and he was an All-American at Armijo. After graduating in 1971, he attended the University of Oregon and pursued hoop and gridiron dreams. His junior year there, he married high school sweetheart and Armijo class of 1970 grad Dianne Smith.

Martin was drafted in 1975 as a defensive end by the New York Giants (jersey number 75). His first impression of the team was…underwhelming. "I couldn't have been more disappointed. The training camp was at a college facility, more like a junior college. No amenities whatsoever. Grossly overcrowded locker rooms, one universal machine—I couldn't believe it. We had better facilities at Oregon. Guys came to training camp forty pounds overweight. When I first got there, a player was smoking in the locker room," Martin said.

Training camp was very different from what it is today. "My rookie training camp was two months long, hitting every day, sometimes three-a-days. We had six preseason games—today they have four. We didn't have water breaks. It was like a war of attrition," Martin said.

The Giants were perennial losers until 1979, when new coach Ray Perkins established discipline and professionalism. When defensive coordinator Bill Parcells was elevated to head coach in 1983, he built on that foundation

George Martin, later a Super Bowl champion, playing his first love, basketball, at Armijo High. *1969 Armijo High yearbook*.

and preached about winning championships. His team of talented players became converts.

The squad in 1986 included quarterback Phil Simms, running back Joe Morris, tight end Mark Bavaro and the "Big Blue Wrecking Crew" defense that included, among others, Martin, Lawrence Taylor and Harry Carson.

"Bill Parcells not only motivated, he educated and demanded perfection," Martin said. "There's a difference between being a football player and being a professional athlete. A professional athlete takes pride in what he does both on and off the field."

The Giants played the Denver Broncos on January 25, 1987, in Super Bowl XXI. Martin sacked Denver quarterback John Elway in the second quarter for a safety that shifted momentum to the Giants, who went on to win their first Super Bowl. It was the lone safety of Martin's fourteen-year career.

"After that game Parcells said, 'Men, for the rest of your lives,' and he repeated it, 'for the rest of your lives, no one can ever tell you that you haven't been a champion'," Martin said.

That 1986 Giants team is credited with creating the Gatorade Victory Shower, a ritual in which the sports drink is dumped on a coach after a victory. "Harry Carson started it and Bill Parcells is very superstitious—if you did something once and we won, you had to do it every time," Martin said. "Once, Harry said he wasn't going to do it anymore and Bill pulled him aside and said 'Oh yes you are!'"

While usually reserved for sporting events, perhaps someone should give Martin a Gatorade shower for all of his off-the-field victories.

Even back when he was a star athlete at Armijo High School, Martin tried to be an example to others. "Armijo football coach Bill Fuller pulled me aside once and said I had a great responsibility in terms of setting an

New York Giants Super Bowl champion and 1971 Armijo High grad George Martin. *George Martin.*

example for classmates, underclassmen and he specifically mentioned my brother," Martin said.

Martin's younger brother Doug, Armijo class of 1976, followed in his older sibling's footsteps. After Armijo, Doug Martin attended the University of Washington and was taken in the first round of the 1980 NFL draft by the Minnesota Vikings. He played ten seasons, racking up fifty and a half sacks and was selected to the Pro Bowl in 1982.

George Martin was a team captain with the Giants and team chapel leader for twelve of his fourteen playing years. For the last two years of his career, he was president of the NFL Players Association.

Martin is remembered locally for visiting schools and offering messages of hope and encouragement to young students, many of whom recall those special visits decades later.

"I was honored to come and went to every school in the district. I talked about goal-setting, having a backup plan and to stay cool and stay in school," Martin said. "When you can impact someone's life as mine was impacted by people I looked up to and admired, I think you've done a great service to society."

Martin received numerous honors after retiring from the Giants in 1988. One that left him speechless was being chosen to induct his coach Bill Parcells into the Pro Football Hall of Fame.

Since his days growing up in South Carolina, Martin had an unfilled wanderlust to see America. One day, he had a brainstorm: he could cross his desire to see more of America off his bucket list while simultaneously raising funds for medical care for 9/11 first responders.

From September 2007 to March 2008, Martin walked more than three thousand miles, from New York City to San Diego. He wore out close to thirty pairs of shoes and raised $3 million, matched by three hospitals. Martin chronicled his efforts in a 2014 book, *Just around the Bend: My Journey for 9/11*.

"It was my way of saying thank you to a group of people who risked their lives to protect our freedoms," Martin said.

Martin's name is on the Ring of Honor at Giants stadium.

Locals shared George Martin memories:

Eugina Hunter-Barnes: I remember when George Martin spoke to a group of us, when I attended Grange. He told us to stay in school and get an education! Left a lasting impression.

Vicky Valentine Proud: I will never forget meeting him when I went to Fairview Elementary School. I was in sixth grade and he looked like…well, a giant.

Phillip L. Jerrell: He attended the Calvary Baptist Church in Fairfield during the off-season. I met him there several times. He was amazingly humble and approachable.

CANDACE LIGHTNER, FOUNDER OF MOTHERS AGAINST DRUNK DRIVING

Candace Doddridge Lightner is the founder of Mothers Against Drunk Driving and is an activist, author and worldwide inspiration. She is also a 1964 graduate of Armijo High School.

When Lightner's father was stationed at Travis Air Force Base, she spent her junior and senior years at Armijo and was the yearbook editor her senior year.

"We called the cheerleaders 'The Golden Girls.' They were the rah-rah popular girls, but my friends and I hung out at Flakey Cream Do-nuts and smoked," Lightner said. "We were known as 'The Cigarette Girls.' Our big thing that we did was read Ayn Rand."

Lightner married, had three children and, after a divorce, was living in Fair Oaks. She lived every parent's nightmare when her thirteen-year-old daughter Cari, an identical twin, was killed by a chronic drunken driver on May 3, 1980.

"Cari was walking to a Catholic school carnival and was hit from behind," Lightner said. "She was thrown 125 feet. The man who killed her was out on bail from another hit-and-run. The police didn't catch him for several days, so I didn't know the particulars."

When Lightner was later filled in on the extensive drunken driving history of the suspect, she asked a police officer how much prison time he would do. The police officer said, "Prison? You'll be lucky if he does any jail time." Lightner was horrified.

"I don't think you could possibly understand the anger and the rage I experienced when I found out that Cari had been killed in the manner which she had and that he was out on bail for another hit-and-run drunk driving crash," Lightner said. "He had been repeatedly arrested for drunk driving with minimal sanctions."

Armijo grad and MADD founder Candace Lightner (*third from right*) with President Ronald Reagan before he signed the National Minimum Drinking Age Act of 1984. *Candace Lightner.*

Lightner launched MADD from her home in 1980. The original acronym stood for Mothers Against Drunk Drivers but was changed in 1984 to reflect the organization's focus on the act and not the individual.

On March 14, 1983, a TV movie titled *Mothers Against Drunk Drivers: The Candy Lightner Story* aired, starring Mariette Hartley. In addition to earning two Emmy nominations, it also gave the organization exponentially more coverage.

Through dogged determination, Lighter and MADD were able to affect significant change in how drunken driving is both perceived and dealt with by the criminal justice system. "During the time I was with MADD, we changed over two thousand laws at the state and federal level and I was personally involved in changing five hundred of them," Lightner said.

A major triumph was the passage of the National Minimum Drinking Age Act of 1984. Lightner witnessed it being signed into law in the Rose Garden at the White House by President Ronald Reagan. It punished every state that allowed people under twenty-one to purchase and publicly possess alcoholic beverages by reducing their annual federal highway apportionment by 10 percent.

After five and a half years, Lightner left the organization she started because, while it did save lives, she needed to live her own.

"MADD did not help my grieving, it helped my anger. I was able to channel my anger into saving the lives of others. I realized I needed to move on and focus on my life and family," Lightner said. "Sometimes what happens when people join or start movements, the focus becomes the death of the loved one. I didn't want Clarence William Busch to make me a perpetual victim. It was my choice to get on with my life in a way that was positive and productive. It led me to co-write the book, *Giving Sorrow Words: How to Cope with Grief and Get on With Your Life* that was published in 1991."

Lightner founded We Save Lives (www.wesavelives.org) in 2013. Its mission is to prevent the three Ds: drunken, drugged and distracted driving.

She is proud to be the inspiration for people to get involved and make a difference. "So many people have started movements as a result of what I accomplished," Lightner said. "I am most proud that other people saw in my work a reason to do something similar that changes a culture, changes laws and saves lives."

THOMAS HANNIGAN:
LOCAL, COUNTY AND STATE PUBLIC SERVANT

Decades before starting a twenty-six-year political career that included stints on the Fairfield City Council, the Solano County Board of Supervisors and the California State Assembly, Thomas Michael Hannigan worked a nonelected job.

As a young boy, he washed dishes for seventy cents an hour at Hannigan's Red Top Fountain (on the corner of Jefferson and Texas Streets), which his father owned. Later, he became a short-order cook at the establishment, preparing the hamburgers and other fare it offered.

Born on May 30, 1940, in Vallejo, Tom Hannigan moved to Fairfield in the second grade.

"Back then Texas Street was Highway 40 and there was no Interstate 80. It was very busy and my dad's business was open 24 hours a day, seven days a week," Hannigan said. "Fairfield was very small then. I think the population was 2,800. The only paved street curb-to-curb was Texas Street. Missouri Street to the south and Empire Street to the north were paved in the middle, but to the curb they were gravel."

After graduating from St. Vincent's High School in Vallejo in 1958, Hannigan earned a degree in business in 1962 from Santa Clara University

and also met his wife, Jan, there. He did a stint in the Marine Corps, went to Vietnam and returned in early 1966 and got into real estate. He opened his own office, Hannigan and Associates, in 1969, next door to Baskin-Robbins on North Texas Street.

Hannigan served on the city recreation commission for four years and was urged to run for city council in 1970. He was elected; two years later, the former paperboy became the mayor of Fairfield. He was instrumental in getting the Anheuser-Busch factory to open in Fairfield.

In 1974, Hannigan won a seat on the Solano County Board of Supervisors then four years later went from county government to state office when was elected to represent California's Fourth Assembly District in Sacramento.

"In the state, I could pick up a phone and solve a problem. I'm talking about social services. I couldn't do that locally because usually counties handle social services," Hannigan said.

During his eighteen years in the assembly, Hannigan served on the ways and means committee that dealt with educational funding, chaired the revenue and taxation committee and, among other issues, dealt with the budget, agricultural labor concerns, water distribution and transportation.

Hannigan became floor majority leader in 1986, a position he held for nine years. Term limits ended Hannigan's political career in 1996, but three years later, he was appointed director of the California Water Resources Board, a position he held until 2003.

Hannigan's wife of forty-three years, Jan, a beloved local educator/principal, died of cancer in 2006. He called his wife "an amazing, remarkable woman." He found love again and married Karen Connolly in 2017. Sadly, Thomas Hannigan died on October 9, 2018, at the age of seventy-eight.

A major accomplishment for Assemblyman Hannigan was the Capitol Corridor train system linking Sacramento to the Bay Area. The intercity commuter rail system went from idea to fruition in just four years (1987 to 1991) and remains among Amtrak's best-performing corridors based on ridership. In September 2019, the Fairfield-Vacaville Amtrak station was officially rechristened the Thomas M. Hannigan Fairfield-Vacaville Train Station.

CELEBRITIES WHO VISITED FAIRFIELD

Over the years, numerous celebrities who are not from Fairfield have visited. The March of Dimes, a nonprofit organization that raises money to prevent premature birth, birth defects and infant mortality, had popular annual fundraising walk-a-thons called Superwalks all over the country.

Locals would get people to pledge a certain amount of money per mile they walked. The Fairfield/Vacaville Superwalk was thirty-two kilometers (twenty miles). Walkers started out at Fairfield High School, then trekked to Vacaville High (via the then-available frontage road) and back again.

To boost participation in the events, the March of Dimes used celebrities. In 1977, brother-and-sister variety-show stars Donny and Marie Osmond made an appearance. The next year, it was Andy Gibb, the youngest brother of the superstar singing trio the Bee Gees and a rising star in his own right.

Superwalk '79 featured an appearance by Robin Williams, who landed in a helicopter at Fairfield High School. He was wearing the orange-and-blue

Daily Republic newspaper coverage of Robin Williams at Fairfield High School for Superwalk 1979. *Fairfield Civic Center Library microfilm.*

shirt with trademarked rainbow suspenders he'd made famous on the hit TV show *Mork and Mindy*. Williams entertained the crowd with a bullhorn and then landed in Vacaville as well.

Other celebrity sightings in Fairfield and surrounding areas include, but are not limited to, the following: basketball legend Michael Jordan at Scandia Fun Center, disco group the Village People at the Fairfield Roller Rink, pop-rockers Night Ranger at Scandia, Fred Berry (who played Rerun on the TV show *What's Happening?*) at Grange Intermediate, Oakland A's left fielder Rickey Henderson at Rod's Pizza in Suisun City, funk pioneer George Clinton at Gordon's Music & Sound and country singer Kenny Rogers at Cordelia Junction.

DID YOU KNOW…?

That, according to a September 28, 1954 Fairfield City Council resolution, the geranium is Fairfield's official flower? It was chosen after careful care and consideration; the qualifications of the geranium had been explored by the beautification committee. It edged out lesser flowers, as it grows easily, has a variety of types and colors and is prolific and perennial.

That the Armijo High School student body staged a strike in 1954 that garnered nationwide press coverage? The walkout was to protest the firing of two popular staff members, teacher John P. Marchak and vice-principal/teacher George Quetin. A delegation of eighteen parents brought allegations to the school board that Marchak had taught atheism and Communism, gave improper sex instruction and had disparaged the Catholic Church. Quetin's contract was not renewed for reasons that are unclear, and the students revolted for three days.

That the Zodiac Killer had victims at Lake Berryessa? On September 27, 1969, college students Bryan Hartnell and Cecelia Shepard were picnicking at Lake Berryessa when the Zodiac threatened them with a gun and then stabbed both of them repeatedly. Shepard was able to give a description of the attacker before she died. Hartnell survived.

That former Fairfielder David Sikes played bass for classic rock band Boston?

That during its formative early years, Fairfield was seen for decades as the pesky kid brother to Suisun City, as the latter was connected to waterways? That changed when Highway 40 went through Fairfield and businesses followed. One of the few remaining vestiges of the old order is the Suisun-

Fairfield Cemetery on Union Avenue that dates back to 1865, when Fairfield founder Captain Robert Waterman donated the land for it.

That Rosie O'Donnell's character in the 1992 film *A League of Their Own* was loosely based on Fairfielder Alice "Lefty" McNaughton? McNaughton worked for the City of Fairfield's recreation department for almost thirty years, coached Little League and, in her later years, coached and played in a men's(!) fifty-five-and-older softball league.

That famed Fairfield Kajukenbo instructor Tony Ramos was sought out in 1969 by now-legendary martial artist Bruce Lee, who was looking for someone skilled in fighting multiple attackers?

That Armijo class of 1965 grad Leigh Stephens was the original guitarist for San Francisco psychedelic/proto–heavy metal band Blue Cheer? Their debut album, 1968's *Vincebus Eruptum*, spawned a number-eleven *Billboard* hit, a raucous cover of Eddie Cochran's "Summertime Blues." In 2010, Stephens was chosen by *Rolling Stone* senior editor David Fricke as number ninety-eight on the magazine's list of the top one hundred guitarists.

That the first directly elected mayor of Fairfield, Bill Jenkins, later became the first directly elected mayor of Suisun City as well? The custom in Fairfield and in many cities before voters decided was for elected council members to choose among themselves who would be mayor and vice-mayor.

SOLANO COUNTY SEAT LANDMARKS

INTERLUDE: THE MEDIEVAL HISTORY OF FAIRFIELD

Once upon a time, Lord Robespierre Waterman surveyed the countryside in his castle atop Cement Hill. The summer heat was stifling in his chain-mail armor, and as he walked from behind the battlements, he hoped to catch one of the breezes for which his Fairfield fiefdom was famous.

He looked down the castle wall at the dried-up moat and made a mental note to assign serfs from nearby Claybank Dungeon to refill it.

Suddenly, the trumpet warning of imminent attack sounded. It came from the east, so Waterman guessed it was the dreaded Vacavillians attempting to plunder his castle again. The wretched telltale stench of onions in the air confirmed his suspicions.

Unsheathing his sword Excalibrate, given to him by the mystical Lady of the Slough, Waterman and his knights fought valiantly, but the Vacavillians, used to the scorching heat, outlasted and overran them.

Before all was lost, Waterman mounted his trusty steed Eye Eighty and, along with three knights who had not been killed, rode across the shire until they came to the hamlet known as Washington Empire.

Waterman had hidden his beloved Maiden Cordelia in the fifty-foot octagonal tower there to keep her from falling into the hands of Vacavillian brutes. Alas, her fortress had become a prison, as the tower was surrounded by knights loyal to the evil Lord Vallejo.

The "castle" on Cement Hill and the medieval-style water tower on Empire Street. *Solano History Exploration Center.*

Waterman and his knights were outnumbered. But spotting an unguarded catapult, he had an idea.

The moment Maiden Cordelia appeared at the top of the tower, Lord Waterman was catapulted in a perfectly executed arc over the top of the structure, where he plucked his startled beloved up with one arm and continued on his arc until landing perfectly in the saddle of his waiting steed.

Lord Vallejo's minions gave chase, but they were no match for Eye Eighty. Waterman and his bride lived happily ever after. The only remnants of their medieval lives are the ruins of the castle on Cement Hill and the remarkably well-preserved tower near Armijo High.

The End.

OK, that was a silly story, but no sillier than some who think that the still-visible ruins on Cement Hill were actually ever a castle, or where the Easter Bunny lives, as one local surmised.

Actually, the "castle" was a rock crusher and is one of the few remaining pieces of physical evidence of the once-bustling town of Cement, owned by the Pacific Portland Cement Company.

From 1902 to 1927, the nine-hundred-acre town supplied cement for concrete used all around the world. The town of Cement had a hotel and a movie theater and was poppin' until the ore ran out and the town died.

The *Daily Republic* used to run an annual interview with the late Donald Heimberger, a Cement City historian.

The land the "castle" sits on has been owned by the Tooby family since the 1940s and was a cattle ranch. Mary Tooby Aiu is tired of trespassers.

"Historical stuff related to the town lives only in history books and in a few pictures. I would think that anyone who goes, or has gone, up to 'the castle' is disappointed as to what they find, which is just concrete towers of nothingness," Aiu said. "There are some who think it is OK to cut fences, paint graffiti and irresponsibly start fires. Many years ago, my brother had the opportunity to blow up the 'castle' with dynamite. My dad decided against it at the time…too bad."

So, view it from afar, daydream all you like—but keep out.

The tower by Armijo High, likewise, was not Rapunzel's crib or a torture chamber or the gallows of Henry VIII that was taken apart brick by brick, transported here and reconstructed—although I must give bonus creativity points for the last ridiculous claim. It was just a water tower built in 1919 with Gothic architecture matching the old jail, now demolished.

You know that classic article "Yes, Virginia, There Is a Santa Claus" that defends the spirit of the holidays and shoots down negative naysayers? This story is the opposite of that.

The Downtown Fairfield Sign

The now-iconic sign that arches across downtown Texas Street and lets visitors know they are in "Fairfield County Seat Solano County" was erected in 1925.

The Fairfield Community Club, a local service outfit, morphed into the Fairfield Lions Club, an affiliate of a larger national organization, in 1925. The sign was its first project. The price tag was approximately $1,000 (the equivalent of more than $13,000 today).

While a special tax made up the difference, the Fairfield Lions Club raised the, well, lion's share of the cost in various ways, including selling $0.50 raffle tickets, with the grand prize a donated washing machine (retail value: $135). The National Electric Sign Company in Oakland was the builder.

The sign's location, in the middle of the block between Jackson and Webster Streets, was chosen, as it was then the geographic center of Fairfield and the busiest downtown block. It was across from Evans & Pyle hardware store, which installed a convenient water fountain near it.

The sign was completed in March, but getting poles that could support its weight created a problem that took months to solve. Finally, the community was invited to an unveiling party on October 23,

Fairfield, Solano County, California; Thursday, October 22, 1925

FAIRFIELD
COUNTY SEAT
SOLANO COUNTY

ELECTRIC SIGN TO BLAZE FORTH TOMORROW NIGHT

UNVEILING CEREMONY WITH MUSIC, DANCING AND MERRY MAKING; COMMUNITY INVITED TO JOIN IN THE CEREMONIAL PROGRAM OF THE EVENING.

A 1925 article in the *Solano Republican* newspaper, predecessor to the *Daily Republic*, about the then-new Fairfield sign. *Fairfield Civic Center Library microfilm.*

1925. According to reports in the *Solano Republican* newspaper, when the sign was switched on, the crowd applauded lustily and then began to party as citizens from ages six to sixty danced to selections by the Fairfield Community Band.

Eighty incandescent light bulbs first illuminated the letters of the sign, but it was changed in the early 1930s to neon. In 1961, the Fairfield Planning Commission suggested the sign be taken down because it was in disrepair. A firestorm of local protest killed that idea; instead, the sign was spruced up by being painted blue and given some detailed work in white and yellow.

For many locals, the Fairfield sign is a source of connection and pride.

Catherine Moy: The red light above it was like the Batman signal back in the day. When activated, police knew there was action.

Mark Smith: The officer on the beat would see the red light on, go to the call box and call to see where the trouble was.

Tanja Duncan: Other than the fact that I like the colors and design of the sign and it gives me that "homey" feeling, I really love the fact that it says "county seat." Whenever I saw the sign, it always gave me a sense of pride,

that out of all the other towns in Solano, Fairfield is the "county seat." Like in a way, we were small-town royalty.

Judy Leetham: I was away at college and my mom sent me an article about the city council talking about taking the sign down. I wrote a letter to Manuel Campos, who used to live across the street from us and was either the mayor or a councilman at the time, and really poured out the horror I felt. He later told my dad: "I took that to the council and we decided we'd better not touch it with a ten-foot pole," and they decided to leave the sign alone. After that, my mom always referred to the Fairfield sign as "Judy's sign." Nice to be "famous" for something, huh?

Harold Hesseltine: In 1957, we moved to Fairfield, and the sign was the first thing my dad pointed out. "This is our new home."

THE CHIEF SOLANO STATUE

In February 1810, the Suisunes, a tribe of Patwin Indians, were invaded by Spanish troops led by Lieutenant Gabriel Moraga. The lieutenant reported that many of them committed mass suicide, but more than likely they were massacred—many burned to death.

Among those captured was a kid who was about eleven named Sina. Some of his homies called him Sem Yeto, a descriptive term meaning "fierce hand."

Sina/Sem Yeto was taken to Mission Delores in San Francisco, and on July 24, 1810, he was made a Christian by baptism and was christened with the new name Francis Solano. He later became a type of American Indian trustee of the mission and helped General Marianno Vallejo quell Indian uprisings. The title "chief" in this case was largely ceremonial and one that was bestowed on him by Vallejo.

In the late 1830s, a smallpox epidemic broke out and did a much more efficient job of quieting tribes hostile to Spanish "progress" by wiping out literally tens of thousands of them. There is speculation that General Vallejo hooked the chief up with a smallpox vaccine. Despite surviving the outbreak, Chief Solano later died of pneumonia.

Solano was one big guy, over six feet, seven inches tall. You'd think someone of his physical and social stature would be hard to misplace, but there has been disagreement about where his remains are. A plaque at Solano

Above: The Chief Solano statue in its original location on a hill near the present-day Interstate 80 truck scales. *Solano History Exploration Center*.

Opposite: A bas-relief of Chief Solano created by Platon Vallejo. *Vacaville Heritage Council*.

Community College commemorates the spot, but others disagree.

In 1933, a contest was launched to create a statue of Chief Solano, and famed sculptor William Gordon Huff's design of a bronze twelve-foot-tall American Indian waving his hand in greeting won. The statue was originally placed on a hill near the present-day California Highway Patrol truck scales on Interstate 80.

Knuckleheads repeatedly vandalized the statue. Consequently, in 1938, it was moved to its present location in front of the old county library.

That didn't stop later generations of knuckleheads, though.

"In 1957, students from Benicia, thinking Chief Solano was the Armijo Indian, painted him their school colors," longtime Fairfield resident Keith Hayes said. "Within a few days, members of their student body had to come and clean it. Of course we were across the street laughing. This was in response to our egging their basketball and rooters' bus as it went through Fairfield a few weeks earlier."

The statue is a Fairfield and Solano County landmark, but is it accurate? Several books and websites say that there are no photos of Chief Solano. The sculptor called the statue's likeness "a figment of my own imagination."

Now, there was a bas-relief sculpture (carved into a rock) of Chief Solano made by someone who knew what he looked like: General Marianno Vallejo's son, Platon Vallejo.

The bas-relief sculpture looks like—no kidding—late improvisational comedian Jonathan Winters. Now, it's possible that Solano was once young and handsome and then in later life looked like the jowly-cheeked Winters. No one really knows.

Speaking of cheeks, one feature of the statue that has inspired snickers for decades is his nude rear end, which was visible when leaving the library. Fairfield resident Mary Pfeifer recalls, "I cried my eyes out every time we drove because my mom would say she was going to give him my underwear."

The cover of a 1960 comedy album by improvisational comedian Jonathan Winters. *Public domain.*

SOLANO COUNTY HOSPITAL

The earliest verifiable reference to a county hospital in Solano County was in the August 17, 1867 *Vallejo Evening Chronicle* newspaper. It was described as "a 10 by 12 shanty, furnished with a pine table, a pine bedstead and a dirty blanket." It was later condemned by the Solano County grand jury.

A hospital was established in 1875 in Fairfield near where Tabor Park on East Tabor Avenue is now located. The property was approximately sixty acres with huge eucalyptus trees to act as windbreaks. A cemetery was located on the grounds, and unmarked graves were used to bury the

dead. The graves were rediscovered in 1965, when a housing subdivision was planned there.

By 1892, the hospital was in bad shape. In a newspaper exposé in the *Evening Chronicle*, the facility was referred to as the "rickety old county hospital." The adjectives "revolting" and "horrible" were among those used.

One of the baffling features of the hospital was its architecture. Even though sixty acres were available for construction, the developers made a thirty-by-sixty-four-foot, two-story building that presented considerable difficulties for those who had to climb stairs to reach the second floor.

The first phase of a new Solano County Hospital was completed in 1920 on what was then Rockville Road and is now West Texas Street.

Built under the guidance of the State Board of Charities and Corrections, the sprawling complex cost $121,477 and was designed by famed Vallejo architect Charles Perry Jr. With its arched windows and Corinthian columns augmented by white stucco and red mission roof tiles, it was a pleasing, fanciful blending of the Italian Renaissance and Spanish Eclectic styles. Over the loggia to the main entrance, the words from Psalm 118 were inscribed: "His mercy endureth forever."

The Solano County Hospital served the community for decades, but changes to health care—specifically Medicaid and the rise of HMOs—were among the factors in the hospital's closing in 1973. It was used as a primary

Solano County Hospital
Fairfield, California
1920-2001

The Solano County Hospital. *Vacaville Heritage Council.*

97

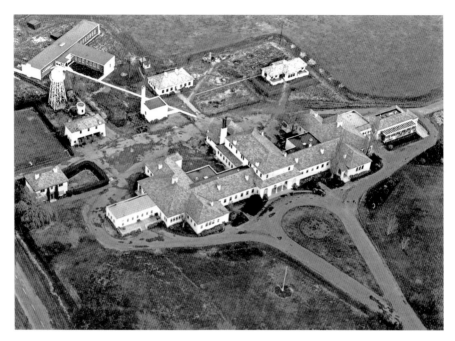

An aerial photograph of the old Solano County Hospital. *Vacaville Heritage Council.*

care clinic for a while, and several of the buildings were used for storage. But it eventually fell into disuse and disrepair.

The hospital did not meet the required criteria to be spared under the California Register of Historic Resources, and it was razed to put up apartments.

Locals looked back on the old hospital site:

Cheryl Hoskins: It's funny that when we had these buildings we thought nothing of it and never really foresaw that that type of architecture would become so rare in Fairfield. Then when these beautiful old buildings are gone, we miss them.

JoAnn Hinkson Beebe: My great-grandfather spent some time there then and was moved by ambulance to Oakland to stay with my great aunt until his passing. Once in Oakland they realized they had forgotten his false teeth. They arrived later that day on the back of a CHP motorcycle.

Steve Murray: My mom ran the county clinics there for many years. Always fighting the bats and cockroaches.

BUNNEY HOSPITAL, FAIRFIELD HOSPITAL AND INTERCOMMUNITY HOSPITAL

In late 1939, the *Solano Republican* announced that Dr. Gordon Bunney, who had moved to Suisun City the previous year with his wife, Esther (yes, Esther Bunney), planned to build a private hospital in Fairfield to better serve the community.

At that time, the Solano County Hospital, which used to be on West Texas Street, did not take private patients.

The Bunney Hospital opened in 1939 at 1234 Empire Street. Dr. Bunney delivered generations of Fairfield residents; their names were listed in the paper as "Bunney Babies."

The facility later became known as the Fairfield Hospital, and locals fondly recall some of the other physicians, including Dr. Campanella, Dr. Gauder, Dr. Green, Dr. Hovde, Dr. Lawrence, Dr. Nesbitt, Dr. Smith, Dr. Valeriote and Dr. Zimmerman, among others.

Despite being enlarged twice, the little green hospital could not keep up with the needs of Fairfield's growing population. In 1954, local civic leaders took action. The Central Solano County Inter-Community Hospital Foundation was incorporated as a nonprofit corporation in 1955. It launched a fundraising campaign to construct a new, thirty-two-bed Intercommunity Memorial Hospital. The cost was estimated to be from $450,000 to $475,000.

On a hot day in early May 1957, the ten-acre site for the new hospital on Pennsylvania Avenue was dedicated. The actual groundbreaking took place nearly two years later, on February 18, 1959. The first shovelful of dirt was turned over by Dr. Felix Rossi Jr., vice-president of the Upper Solano County Hospital Foundation. Unlike the dedication two years earlier, the groundbreaking was a muddy slosh-fest, but nonetheless Dr. Rossi called it a "great day" after all the years of fundraising efforts.

On January 3, 1960, the Intercommunity Memorial Hospital officially opened and patients were transferred from the Fairfield Hospital. The 32-bed hospital was built to be expandable, and by 1968, it was, raising its capacity to 80 beds. In 1979, a new, $7.9 million Intercommunity Hospital with 108 beds opened. In 1986, after a corporate reorganization, it became NorthBay Medical Center.

Locals shared remembrances of the hospitals:

Rita Martin Proctor: I spent way too much time at the Fairfield Hospital as a child. Dr. Green was my doctor. He made house calls. One time I saw him coming down the driveway and was so excited that I jumped out of bed and broke my parakeet's leg. He put a little cast on it and he healed up just fine. What a sweet man.

Krystie Reed Champion: I was born at Intercommunity Hospital the summer of 1972. My last child was born at NorthBay in 2005. My mother left me and went home to Jesus from there in January of 2018. Lots of history for me in those halls.

IWAMA MARKET

It seems incongruous that a lonely, ramshackle building sitting on 1.7 acres on Rockville Road near Willotta Oaks could elicit fond memories from locals—much less be a catalyst for works of art. Yet the long-closed and decaying Iwama Market, now mainly a home for countless bats that come out at dusk, manages to be an oxymoronic beloved eyesore.

Wealthy rancher Lewis Pierce, who came to Suisun Valley in the mid-1800s, used to own the property the market sits on. The building was erected in the 1870s as a horse barn. When Rockville Road became Highway 40 in the early twentieth century, the spot became a gas station.

In 1927, it became Bandana Lou's, a family-owned restaurant. It was famous for its southern-fried chicken, potatoes and biscuits served with honey, all wrapped up in red-and-white-checkered cloths. Tables and chairs in the place surrounded a dance floor, where locals would get their groove on to live bands.

The building served as a clubhouse for U.S. Army Air Force personnel during World War II, and after the war, descendants of the original Pierces leased it to a former employee who had returned to the area. He didn't return from European or Pacific battlefields, but from the Gila River Japanese-American relocation camp where he and his family had been forced to move out of fear following the December 7, 1941 Pearl Harbor attack by the Empire of Japan.

In 1946, first-generation (Issei) Japanese immigrant Frank Fumio Iwama (the "I" is pronounced "eee") opened Iwama Market. A 1949 Classified Directory published in the *Solano Republican* newspaper that highlighted local businesses listed the market's wares as "groceries, fresh meats & fish, Oriental foods and fresh bait. Phone number 23-F-21."

The exterior of Iwama Market on Rockville Road. *1977 Armijo High yearbook.*

After Iwama died in the early 1960s, the land was leased to the Asahara family. Then, in 1962, Albert and Annie Hom took it over and, along with their children, ran the market for over two decades.

The literal mom-and-pop shop was known for great prices and service, quality produce and a fine butcher shop specializing in marinated meats.

Jeff Hom was five when his parents bought the store. At that time, he spoke Chinese, English and Spanish fluently. The latter was because a huge number of customers—upward of 80 percent by Hom's estimation—were migrant farmworkers from South America. And, oh, did they like to party after a hard day of work.

"In the summer months, July through September, we sold more beer than any other store did for the entire year in Solano County," Hom said.

In 1985, Ramzi and Janan Totah bought the business. It is now abandoned, and its ownership is unclear.

Other locals shared Iwama Market memories:

Doug Rodgers: As kids, we'd stop there on our bicycles and get small containers of chocolate milk to drink and bananas to eat. I always wondered, what was upstairs?

Debra Merritt Bruflat: I can remember the smell of that store. My friend Louise lived close by, and we would walk there and buy little candies wrapped in paper. You ate the candy with the rice paper on it.

Ron Lancaster: My dad would take us for a drive and it seemed like we'd always end up there. He would buy us ice cream and we'd sit in the car and listen to country music. Last time I was home, I drove out there. It brought tears to my eyes.

Iwama Market inspired a 2011 poem by Suisun resident Steve Federle and paintings by two artists, Carmel Valley's Daphne Wynne Nixon and Benicia's Donna Covey. Covey grew up in Willotta Oaks and posted remembrances on her website, www.djcovey.com: "I remember Iwama Market as the place where we bought rice paper candy and where Tonto the not-so-friendly Shetland pony was housed behind the store. I vividly recall in the 1960s the parking lot was full of life and fiesta when the hard-working migrant farm workers gathered at the end of the day to unwind, drink beer and play music. And of course the parking lot was always the meeting spot for my friends and I to begin our bike rides around the Suisun Valley 'loop.'"

An interesting coda is that Frank Akira Iwama, the son of the original owners, became an attorney and had a distinguished forty-five-year career before his death in September 2016. Iwama's earliest memories were of growing up detained in the relocation camp. According to his obituary, he "later successfully represented the Japanese American Citizens League

in the effort to obtain redress from the United States government for wrongful detention of Japanese Americans in internment camps during World War II."

THE LEGACY OF B. GALE WILSON: ANNEXATION OF TRAVIS AFB AND LOCAL LANDMARKS

A 1988 *Daily Republic* newspaper column referred to Fairfield city manager B. Gale Wilson, who was retiring after thirty-two years, as "the chief architect of modern Fairfield."

"Countless events and personalities helped bring Fairfield to where it is today, but Wilson looms large as the major influence of his time. Wilson's efforts and visions, more than those of any mayor, any council member or any other citizen have shaped Fairfield's modern era," the article said.

Among the numerous city-defining landmarks that bear B. Gale Wilson's fingerprints are the Fairfield Civic Center complex, Rockville Hills Regional Park, the Anheuser-Busch factory and Solano Town Center mall.

Byron Gale Wilson was born on July 6, 1929, on a kitchen table in a log cabin in Tridell, Utah. His family moved to Roosevelt, Utah, when he was four years old, where they ran a 160-acre farm.

A member of the Church of Jesus Christ of Latter-day Saints, Wilson went to college at Brigham Young University, but after his freshman year was called to go on a mission trip to Ontario, Canada. There he served as a district president and learned the art of leadership. "It gave me a taste for management. I was responsible if a widow's house burned down—and

Former Fairfield city manager B. Gale Wilson in front of the civic center pond in 2018. *Tony Wade*.

that happened once," Wilson said. "I had to be Johnny-on-the-spot. I had a checkbook in the name of the church. I learned to solve people's problems."

After the mission trip, Wilson finished his schooling at BYU and the University of Southern California. He was hired as the assistant city manager in Buena Park in Orange County and worked there for a year and a half.

Fairfield was searching in 1956 for a new city manager, as its first one had resigned after only two years. Fairfield mayor Chris Santaella hired Wilson, who, at only twenty-six, became the youngest city manager in the country.

One of the most remarkable and impactful accomplishments that Wilson achieved, with others, was more than doubling the size of Fairfield and boosting its population by approximately 60 percent.

In just 26 days.

As early as 1960, there was talk of the City of Fairfield annexing Travis Air Force Base. If it could be pulled off, it would be a win-win for the city and for the base. "Certain funds were available to cities and counties on a per capita basis. So the question became, how do we annex Travis?" Wilson said.

The annexation was possible because of a government code that allowed cities to initiate annexation proceedings of federal territory if the affected agency gave its consent. Negotiations between the city and the base began in earnest in 1965.

The annexation process was one of several times Wilson made sure the groundwork was properly laid and then kicked the door down when opportunity knocked.

Wilson and Fairfield mayor Arne Digerud embarked on a whirlwind trip on March 1, 1966, to the Pentagon in Washington, D.C., to get final U.S. Air Force approval. Three days later, they were back in town with the OK.

The newspaper said, "The speed with which they were able to carry their application through higher governmental echelons was termed 'fantastic' by veteran observers of Pentagon affairs."

They presented it to the Fairfield City Council at a noon meeting on March 4, where it passed unanimously.

Next, it had to be presented to the Local Agency Formation Commission of Solano County, where there was a fifteen-day waiting period. If sanctioned by the LAFC, it would then be presented to the Solano County Board of Supervisors, which would hold a public hearing, then vote on it. Finally, it would have to be certified by the California secretary of state.

A vintage Travis Air Field (later Travis Air Force Base) postcard. *Public domain.*

Potential snags were everywhere, and time was of the essence. If it managed to clear all necessary hurdles by April 1, Fairfield would receive approximately $100,000 (over $800,000 in 2021) more in motor vehicle license fees. They were apportioned based on the population of California cities on that date.

Two days before the deadline, on March 30, 1966, the proposal was certified by the California secretary of state.

The Travis annexation increased Fairfield's population (from 28,000 to 44,000) and more than doubled its acreage (from 4,264 to 9,096).

More than fifty years later, Travis Air Force Base is still the largest employer in Solano County.

Locally, B. Gale Wilson K-8 School and B. Gale Wilson Boulevard (in front of NorthBay Healthcare) both honor the longtime former Fairfield city manager who served from 1956 to 1988. His philosophy was, "If there's going to be a parade, better to lead it than to be run over by it."

Wilson's numerous accomplishments, which helped sculpt a small farming community into a modern Bay Area city, are too many to list, but what follows are a few touchstones.

ROCKVILLE HILLS REGIONAL PARK, PURCHASED 1966

In 1966, Wilson saw a subdivision map of Rockville Hills with a proposed three-hundred-unit housing development to be built there. To stop the encroachment and preserve the 383 acres from development, the city bought the land. It became upper Solano County's first large recreation area.

"We had to take bold action. I saw no other way to stop it and stop it with finality," Wilson said. "I think the vision of that project has blessed the whole area."

FAIRFIELD CIVIC CENTER, DEDICATED 1971

One of Wilson's first moves as city manager was to arrange for Fairfield to purchase Waterman Park, a federal housing project that had been erected in the 1940s for military personnel. The funds that Waterman Park residents subsequently paid the city for rent for decades helped fund the project that eventually took its place, the Fairfield Civic Center.

By the late 1960s, Waterman Park was less-than-optimal housing.

"The city council meetings were held in an administrative building there and there was a big crack in the cement floor. I had to be careful that my chair didn't get stuck in it," Wilson said.

The city held an architectural contest in 1967, and the winning design, by San Francisco architect Robert Hawley, became the thirty-three-acre civic center complex, featuring a figure-eight pond with a fountain.

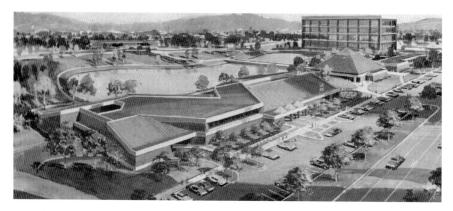

An artist's rendering of the Fairfield Civic Center project. *Solano History Exploration Center.*

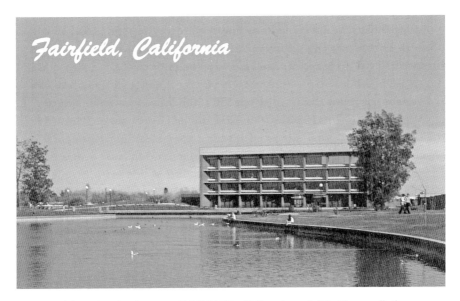

A postcard featuring the then-new Fairfield City Hall and pond. *Tim Farmer collection.*

An aerial shot of the Waterman Park Federal Housing Project. *Tim Farmer Collection.*

Wilson described the process as going from the "worst to the best." On May 29, 1971, 650 people attended the dedication ceremony for the new Fairfield Civic Center. Built on the thirty-three acres where the Waterman Park federal housing had once been, the civic center featured a figure-eight, man-made lake; City Hall; police administration building; council chamber; and community center.

Anheuser-Busch Factory, Opened 1977

Part of the job of a city manager was to schmooze potential investors. In the early 1970s, Budweiser bigwig August Anheuser Busch came to town, as the beer company was deciding whether to build a brewery in Fairfield. Wilson took Busch and the mayor to dinner at one of Fairfield's fanciest restaurants.

"The next day the mayor called and said the restaurant owner was complaining because I didn't leave a tip," Wilson said. "The mayor asked me why I hadn't. I said I didn't leave a tip because I was sitting next to August A. Busch and I looked over and noticed that in the middle of his soup was a big fat fly. It's a great story…to forget."

Despite the dining faux pas, Busch still brought a Budweiser brewery to Fairfield.

Solano Mall, Opened 1981

JCPenney was always to be the anchor for a proposed Fairfield regional mall. In 1966, a sign was erected on Pennsylvania Avenue and Travis Boulevard announcing the mall and JCPenney's impending move there from downtown.

That move took six years to happen.

It was another *nine years* until the mall opened.

The delay wasn't for a lack of effort. It came down to one of Wilson's core beliefs and community goals of doing the job right. In negotiations with mall developer Ernest Hahn, Wilson frowned on the tininess of the mall Hahn proposed and then repeatedly asked him if he liked to make money. When Hahn replied, "of course," Wilson told him to do the job right.

Wilson sweetened the deal by offering concessions—among them, moving K.I. Jones Elementary School and paying for other improvements by forming a redevelopment area.

Right: The Anheuser-Busch factory in Fairfield. *1978 Armijo High yearbook.*

Below: A JCPenney ad after the store moved from downtown and before the Solano Mall opened in 1981. *1978 Armijo High yearbook.*

Solano countys' most complete dept. store

Store Hours:
Mon. thru Fri. 10 a.m. to 9 p.m.
Saturday 10 a.m. to 6 p.m.
Sunday 12 noon to 5 p.m.

Charge It Now

JCPenney

©1977 JCPenney Co., Inc. —1330 Travis Blvd. Fairfield — 422-0320

An artist's rendering of the interior of the Solano Mall. *Tim Farmer collection.*

"Then the dramatic moment happened that I'll never forget. [Hahn] pointed his finger at the architect who was looking at those miserable plans and said three words: "burn those plans!"" Wilson said.

In 1988, B. Gale Wilson received an award from the International City Management Association for "outstanding contributions to the art and science of local management." The annual award goes to just three of the organization's eight thousand members.

B. Gale Wilson died on September 1, 2020.

In an interview done two years before his death, he looked down from the fourth floor of the Fairfield City Hall onto the fountain, ducks and geese and said, "That is a beautiful view. I think we did some things right."

UNIQUELY FAIRFIELD STORIES

The Fairfield Area Rapid Transit, or FART Bus

In the late 1970s, the rather crass word for the bodily function commonly called "passing gas" in the destination signs of buses in Solano County's seat was not a prank. It was indeed the Fairfield Area Rapid Transit, or FART bus.

In the face of competition from Sprint, AT&T consolidated some of its operations and shifted numerous employees from various other cities to San Francisco. Many of those employees settled in Fairfield and other suburbs and commuted to the city. One of them was Al Cardenas Jr., who still resides in Solano County's seat.

"All the AT&T employees who lived in this area commuted to San Francisco every day and a co-worker named Bill Childs saw a business opportunity," Cardenas said. "He asked us if he got a bus would we ride it and we all agreed."

The unorthodox name for the new bus line was simply a play on the Bay Area Rapid Transit (BART) trains and local Dial-a-Ride Transit (DART) vans. Childs worked in the marketing department at AT&T, and he used those skills to entice riders beyond his coworkers, and soon they had to add another bus.

The gas shortages of the 1970s were referenced in the destination sign: "Gas Pains? FART to San Francisco." Advertisements and the "are you kidding me?" name of the bus helped spread the word locally.

The original Fairfield Area Rapid Transit, or FART, bus that ran round-trip between
Fairfield and San Francisco. *Neil Taylor.*

After a few years, AT&T relocated to Pleasanton, so the FART added a
run there. Eventually, the system had about six drivers who would take turns
driving for a week and not have to pay for their commute.

While the FART flourished, it was not without challenges. Childs
struggled to find a place to park the bus overnight and would often leave
it on a Fairfield side street until the police made him move it. He later
found a spot off Peabody Road and Cement Hill Road. Also, doing
maintenance on his diesel buses in front of his house didn't go over well
with his neighbors.

The audacity of giving a bus such a controversial name seems to have
reflected the fun-loving spirit of those involved. Cardenas related stories of
decorating the inside of the buses for Christmas as well as taking trips to the
Renaissance Pleasure Faire when it was still held in Novato.

The buses had an onboard bar on the way home but were not equipped
with bathrooms. According to Cardenas, the record a rider set for onboard
beer consumption from San Francisco to Vacaville without a bathroom
break was ten beers.

"One time, though, we had a situation when a FART bus was out of
commission, so Bill had to rent a bus, which did have a bathroom on it,"

Cardenas said. "Well, there was one rider who was a real big mouth who no one cared for.

When he went to the bathroom, they locked him in. He was in there from Berkeley all the way to Fairfield. Ooh, he was mad! That was the kind of rapport we had. We worked hard together and partied together."

Local actress/singer/dancer Liz Towne Andrews's experience with the FART bus was anything but fun: she rear-ended one.

"We were at a stop sign, and the bus started to go, so I was rolling forward, and was distracted waving at a friend and I didn't notice that the bus stopped again," Andrews said via email. "The bus driver got out and was really mad at me and said he needed a police report. The funny thing was, there was no damage to the bus, but my front grill was crushed. I talked the driver into skipping the police report because I needed to get to the theater!"

The FART crew also had a softball team that used to play other local companies at Todd Park in Suisun City. Cardenas still has a picture of them on display in his home.

Eventually, the FART buses faded away in the late 1980s, when AT&T employees started to retire and Bill Childs moved away.

As time goes by and memories fade, some Fairfielders have confused the DART (Dial-a-Ride Transit) and the FART buses. DART was (and is) run by the City of Fairfield, and it officially began service August 11, 1975. The

The later Fairfield Area Rapid Transit, or FART, bus that ran round-trip to Fairfield and San Francisco. *Neil Taylor*.

The DART (Dial-a-Ride Transit) vans that debuted in 1975. *Vallejo Naval & Historical Museum.*

concept was to provide affordable doorstep-to-destination transportation service to anyone in Fairfield.

Patrons called 429-2400 and gave the dispatcher their information. Then one of five green-and-white, air-conditioned, thirteen-passenger vans would show up within thirty minutes. A loud, distinctive, three-tone horn would signal DART's arrival at a pickup location. The patron would then be taken to their destination, often with some route deviations to pick up more customers.

It was a great bargain at a mere fifty-cents-per-person fare.

DART preceded FART, so it could not have become it. Also, DART was (and is) a fleet of vans, while the FART were buses. DART was and is run by the City of Fairfield; FART was a private company. DART was for local transportation; FART went to and from San Francisco daily. They were always two completely different things.

Locals should be glad that BART (Bay Area Rapid Transit) trains never came here, or heads would've exploded.

THE FAMILY THAT LIVED
IN THE SOLANO COUNTY JAIL

During the 1950s and 1960s, a room in the Solano County Jail had wallpaper featuring ballerinas wearing pink, blue and yellow tutus. It wasn't an attempt to humiliate the prisoners, as was tried decades later in Arizona by making the inmates wear pink underclothes.

This will require some explaining.

Judy Emerson Gosselin's family lived in the jail, which used to be next to the old courthouse on Texas Street, because her father, Stanley Emerson, was appointed undersheriff of Solano County. The Emersons had resided on Taylor Street until she, her sister Susan, her parents and pet cocker spaniel Penny moved to the jail around 1955, when Gosselin was approximately eleven years old.

"My dad's position required that he reside on the jail premises and also that my mom, Lillian, serve as chief matron," Gosselin said. "The chief matron was a sworn-in female officer who took care of the women's ward. They needed someone on-site who could book female prisoners at night if needed. They were on call twenty-four hours a day/five days a week."

Solano County undersheriff Stanley Emerson and Chief Matron Lillian who, with their two daughters, lived in the Solano County Jail for over a decade. *Judy Emerson Gosselin.*

"We had a private entrance from the side alley between the courthouse and the jail. The residence was on the second floor and had a kitchen, living room, bathroom and two bedrooms," Gosselin said. "Our windows were not barred like the others, and my bedroom faced the old Armijo [now the courthouse]. It was over the drunk tank."

The first Solano County Jail was constructed in 1859 and was replaced in 1908 by a larger building that resembled a medieval fortress. In 1919, the fifty-foot-tall octagonal water tower was added, with architecture mirroring the jail's. After World War II, the jail was remodeled and finally was demolished in 1991.

As a child, Gosselin found the rich shrubbery on the jail grounds ideal for playing hide-and-seek. Later, her father taught her how to fly-fish on the jail's big front lawn. While she was a tomboy, she also took dance lessons—hence the aforementioned ballerina wallpaper.

In her time living at the jail, Gosselin befriended staff members. One deputy taught her how to take fingerprints and how to take and develop photographs. One of her favorite people was the jail's cook, Thelma "Tom" Tonnesen.

"She was [longtime Fairfielder] Bud Tonnesen's mother," Gosselin said. "She let me hang out in the kitchen and watch her cook. Tom was a great cook and made wonderful cookies. My dad and I still make Tom's jailhouse beans."

Gosselin also befriended inmates. The family's subsequent dog, Jody, would wander into cells, and the inmates built him a doghouse on the exercise yard.

"I got to know some of the trustees. They were there for minor offenses like being drunk in public," Gosselin said. "They would be sober in jail and just be wonderful people."

Once, Gosselin's father and a deputy tried to figure out how prisoners were getting contraband into the jail. They set up a stakeout in her bedroom with the lights out and the blinds pulled. A string came out of the prisoner's side, and someone on the sidewalk tied something on it and it was retracted. Busted.

Gosselin had slumber and birthday parties and other normal teenage gatherings in her family's jail home. Her last party there was for her 1964 engagement. During high school, Gosselin was very social and well known, and she was homecoming queen.

"When I was in school there were three distinct groups; the town kids, base kids and valley kids. I had friends in all three groups and they visited me in the jail. It was also fun to bring a new boyfriend home to meet my parents," Gosselin said.

She found there were pros and cons—no pun intended—to being known as one of the girls who lived in jail.

"I had a group of girls in my car and was sitting at the signal when a carload of boys pulled up and challenged me to a drag. We took off and I was inching ahead when the lights came on behind us," Gosselin said. "The boys went right and I went straight. The police officer chose the boys because he knew where to find me. The next day he pulled me over and said, 'Either you tell your dad, or I will.' I lost my driving privileges for a while."

When they finally moved out of the jail, Lillian Emerson was glad to move to their house in the Suisun Valley "with a backyard at last." Their old quarters were renovated and housed the ID department and offices.

INTERLUDE: TRAIN DERAILMENT!

I am not one usually given to sensationalism, but in this case it is warranted. This derailment involves the FBI! U.S. Navy SEALs! White phosphorus! Sabotage! Really!

At approximately 1:00 a.m. on March 19, 1969, a southbound forty-car train derailed in a remote area near Chadbourne Road adjacent to the Suisun Marsh. Thirty-one cars went a-flyin'. Unfortunately, two of them contained ninety tons apiece of liquid white phosphorus. They ruptured.

White phosphorus ignites when it comes into contact with the air. The resultant firestorm was fierce. The Solano Fire Protection District was aided in the firefight by U.S. Navy SEAL underwater frogmen from Mare Island who happened to be training nearby when the derailment occurred.

Once the flames were extinguished, there was still the matter of what to do with the two cars nearly filled with white phosphorus that were half-buried in the mud. Twenty-eight hours after the derailment, the decision was made to bury them there and cover them with an unreinforced concrete cap and fence it off with obvious warning signs.

A third car was also buried, but it had only corn in it.

After a preliminary investigation by the Solano County Sheriff's Office and Southern Pacific, foul play was suspected and (cue the Efrem Zimbalist Jr. show's music) the FBI was notified.

Evidence was found that the track had been altered. Rails on the track were disconnected, and a heavy object had been placed on them. The FBI called it "an intentional derailment."

It looked like a case of (cue the Beastie Boys song) sabotage.

The aftermath of the 1969 derailment of railroad cars containing white phosphorus. *Irving Scible.*

It could have been much worse, because that track was Southern Pacific's main line for passenger trains entering and leaving San Francisco. No one was ever caught for the crime.

Meanwhile, the phosphorus train cars (and the one full of harmless corn) remained buried for decades. In fact, they are still there.

I was intrigued when I learned about the white phosphorus crash site and went directly from the microfilm machine at the Fairfield Civic Center Library to the site at the end of Chadbourne Road. Keep going past where the road is no longer paved and come to a dead end, and you will see the fenced-in area with the signs warning of white elemental phosphorus.

The site is monitored annually, and in 1998, a deed restriction was recorded that bars it from ever being developed. It lists specific things that can never be built there, just in case someone gets a wild hair to plant a daycare center, school or hospital in a marsh area right next to the train tracks where white phosphorus is buried. In 2017, Suisun City included an update on the buried phosphorus trains in a Local Hazard Mitigation Plan.

THE SPLENDOR OF WONDER WORLD

When a Walmart superstore opened in Fairfield, it was big news. But it couldn't hold a candle to the debut of what many locals call the original Fairfield superstore: the Wonder World Shopping Center.

Located at 1833 North Texas Street, Wonder World, with "45 great departments and an ultra-modern supermarket," was launched on July 29, 1964, with serious fanfare.

Free balloons for the kids. Free orchids for the women. Thousands of dollars in prizes. The grand prize was a drawing for a twenty-one-inch color Motorola television in a walnut cabinet.

Items for sale included Remco Beatles dolls for $1.11 each. Now considered vintage, dolls in mint condition are worth a tad more than that. Also available were LP records for $0.48 in many genres, including jazz, Hawaiian, show tunes and classical. A Eureka floor polisher/scrubber was available for $15.81, with a free ten-day home trial. This was before the dreaded 15 percent restocking fee. A Magnus home entertainment center could be had for $44. In 1964, home entertainment centers weren't video game consoles. They were…wait for it…organs.

In the *Daily Republic* a couple of days later, Wonder World thanked the more than fifty thousand people who came to the grand opening.

Fifty thousand? That's questionable, but either way, it is impressive—whether that many people actually did shop there or the Wonder World PR staff inflated the estimate with such chutzpah.

Wonder World had an all-in-one bakery, a farmers market, a retail store and a café. Customers could walk in the main entrance and enter other stores inside like a mini-mall.

Nearly every local remembers Wonder World's iconic sign with a globe stuck between two W's, which made the appropriate word, *WOW*. Some youngsters back then thought it was an amusement park. They were soon proved kind of correct, as annual carnivals took place in the parking lot.

In the 1960s, Daylin Corporation, which started as a drugstore company, expanded its empire, acquiring and absorbing several companies. Among them in 1966 was a chain called Disco Department Stores. "Disco" was simply short for "discount."

Daylin acquired Wonder World in 1967, and the Fairfield one became Disco Wonder World.

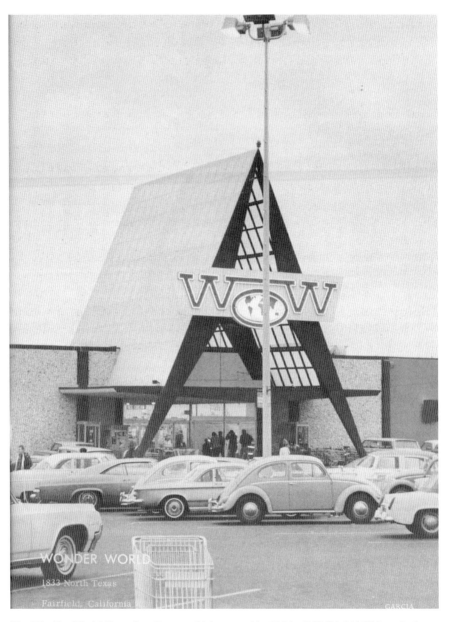

The Wonder World Shopping Center, which opened in 1964. *1967 Fairfield High yearbook.*

Like many businesses, Wonder World eventually faded from Fairfield, but a family of owls nested in the old WOW sign that faced North Texas Street, and it stood for years as a kind of holdout memorial to what once was. Wow.

Locals looked back on Wonder World:

Patti Thoming: It was such an exciting store, you could buy anything there like Walmart!

Bobbie O'Halloran: Oh I just loved going to the carnivals. I was terrified of the Zipper, and of course we had to ride it a million times!

Christy Thompson: Wow (no pun intended)! When I look at pictures now it looks so small and I remember it as being so huge. I had one of those terrifying I'm-lost-because-my-mom-is-one-aisle-away moments in Wonder World. I can still remember the feeling.

Johnny Colla: As you walked through the front door, hundreds of records were for sale about forty feet in on the left side. Wonder World had some deal with who-knows-who to stock what were called "cut-outs": LPs that record labels couldn't sell, then offered up to Podunk outlets for pennies on the dollar. I bought records by Howlin' Wolf, Jimmy McCracklin, Ray Charles, James Brown, Robert Johnson and a plethora of obscure psychedelic acts… all for somewhere between seventy-nine and ninety-nine cents a record. I still have every one of them.

INTERLUDE: THE TREEHOUSE ON WALTERS ROAD

I don't remember the first time I saw the four-story treehouse on Walters Road. It was probably in the mid-1970s, because part of the bus route to Grange Intermediate School was on the then-two-lane road.

I do recall quite clearly, however, the first time I got to go inside the treehouse. It was 1982, when I was taking a sociology class at Solano Community College taught by the treehouse's builder/owner, Glen Gaviglio.

He would often invite us to treehouse parties after class. I remember the thrill of walking up the staircase to his house among a grove of enormous eucalyptus trees.

Gaviglio was a professor at Solano College for thirty-seven years, then he taught online classes for ten years after retiring. I called him out of the blue to get a quote for an article and inquired about his treehouse. He had continued to add on to it since the last time I had been there, but he has now retired not only from teaching but also from building.

The idea for the treehouse started with a student at Solano College in 1973. "I had a crazy hippie friend named Rocky who lived in a bus he'd converted into a place to live and he said, 'You know, you should build a treehouse and I know where we can get some wood,'" Gaviglio said. "We went to the Vallejo docks and got salvage wood. Rocky had a rack on top of his bus, and he made a tripod with a pulley on it, so we could pulley up sixteen-foot-long telephone poles."

The idea was for the treehouse to just be one room, but Gaviglio, who had always been fascinated with construction, soon became an obsessive builder.

By 1979, Gaviglio's treehouse sat on five eucalyptus trees and nineteen pilings. His creation was featured in newspapers from Los

Glen Gaviglio's four-story treehouse on Walters Road. *Tony Wade.*

Angeles to St. Petersburg. Florida. There was also a blurb titled "Me Tarzan, You Wipe Your Feet" in the December 1980 issue of *Popular Mechanics*.

At that time, the treehouse featured eleven rooms, sliding glass doors, curved stairways and a sunken fireplace. Since it was anchored to trees, when the wind blew, it would move and creak like a ship.

While many were impressed with Gaviglio's treetop dwelling, the Solano County Planning Department was not. One day, a seven-man delegation showed up on Gaviglio's two-and-a-half-acre lot and told the professor that he was in violation of building codes.

"The planning department said I could only have one residence on my property. I had a house and the treehouse was also a house. The choices were to rip out the kitchen in the treehouse or move the house. So I moved the house to the other side of Fairfield and sold it. It's still there on Hamilton Drive near the DMV."

In 2002, construction began on the nearly six hundred homes in the Peterson Ranch subdivision, and Gaviglio refused to sell his land. So they built around him. Since his property stretched westward onto what is now the four-lane Walters Road, he was given two parcels in compensation.

For nearly thirty years, his house was on unincorporated county land, but it is now in Suisun City at the end of the cul-de-sac on Fort Ord Court. ("No Trespassing" signs are posted.)

When revisiting the treehouse after more than thirty years, one new feature stood out: the elevator. It is about the size of a large closet with accordion doors on either side. Once reaching the top floor and opening the door, only one word suffices: wowzers.

The rather rustic and seemingly haphazard exterior of the treehouse only amplified the stunning beauty of its ultramodern interior. The hardwood floors, granite countertops, stained-glass windows and decorative skylights are absolutely breathtaking.

Gaviglio's treehouse is complete with all the latest amenities, including a man cave with the requisite comfy chair, huge TV and video games like *Assassin's Creed*.

When he built the elevator, the city had him get a structural engineer to inspect his place. It is now not attached to eucalyptus trees but firmly embedded in concrete. As for sturdiness? "It can withstand eighty-five-mile-per-hour winds and an earthquake," Gaviglio said.

The Fight to Save the Armijo Auditorium

The old Armijo Auditorium was located on the southeast corner of Texas Street and Union Avenue and was connected to the old Armijo High building, now the Solano County Courthouse.

Constructed in 1930 at a cost of $50,000, it seated more than eight hundred people. The auditorium was built in the Spanish Colonial Revival style and featured classical pilasters on its concrete walls and a red-tiled roof.

Many long-timers who attended events in the auditorium speak in hushed tones about its beautiful red velvet drapes hanging from golden rods and beautiful windows. But what they most remember were the extraordinary acoustics. Some recall being able to whisper on stage and hear it in the balcony.

While theatrical events, graduations and citywide entertainment took place there, it wasn't until 1961 that the venue's full potential was realized. A February 19, 1961 *Solano Republican* newspaper article heralded the beginning of local dentist Dr. Rashid's determined efforts to bring some real culture to his adopted hometown of fifteen thousand people.

"Dr. Philip J. Rashid, displaying hitherto unsuspected talents, has organized a local theatrical group named the Belfry Players. He is directing them in their first public performance—a play entitled 'The Upper Room' at the Armijo High School Auditorium on March 18 and 19," the article read.

While his theatrical skills may have been news to locals, in addition to achieving bachelor's and master's degrees as well as his doctorate in dental surgery, Dr. Rashid also majored in speech and dramatics in college.

The Upper Room was a local sensation. One review raved: "Under the inspired direction of Dr. Philip Rashid, a troupe of amateurs with a mere five weeks of preparation created a passion play titled 'The Upper Room.' The costumes, music, and sound effects were remarkable. Recordings which had been specially made for the production in New York of the thunderstorm and sounds of the nailing to the cross were indescribably vivid. Many in the audience were moved to tears."

At the opening, Dr. Rashid read letters of congratulations from California governor Edmund G. Brown and Academy Award–winning actress Joan Crawford.

Dr. Rashid later directed and produced numerous Belfry Players shows staged at the auditorium.

It was a different time, as evidenced by a promo for the Belfry Players' production of *A Funny Thing Happened on the Way to the Forum* splashed on the front page of the May 23, 1968 edition of the *Daily Republic*.

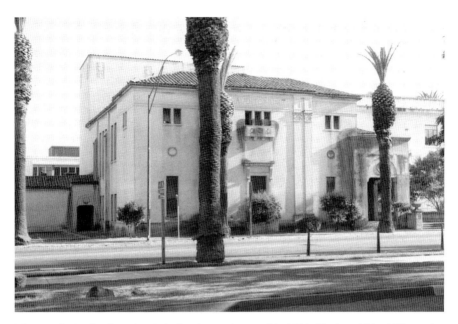

The Armijo Auditorium shortly before it was destroyed in 1985. Black mold is visible on the front of the building. *Tim Farmer Collection.*

The *Forum* shows may have been the last performed there, because a fire, vandalism and general disrepair caused the auditorium's closure that year. The state deemed it an earthquake hazard as early as 1962.

In 1972, the Fairfield City Council ordered a feasibility study to see if the auditorium could be renovated. The study concluded that it could, and the city committed $245,000 to the project, provided the balance of the funding could be raised.

The Armijo Memorial Auditorium Foundation, Incorporated was formed around 1973 and was spearheaded by Gordon Gojkovich, Rashid and others. Fundraising events included everything from a dance-concert featuring regional favorites Sons of Champlin, with local bands Runnin' Strut and Emmet Otter opening, to a white elephant sale by a sorority that raised forty-five dollars.

"I was a senior at Fairfield High and in the Scarlet Brigade Band in 1972–73," William Dean said. "We voted to donate the money we'd raised for band trips to save the old auditorium. It would be interesting to find out what happened to all that money."

In 1974, the Fairfield City Council hired the Spink Corporation from Sacramento to do a more in-depth feasibility study for $14,000. That

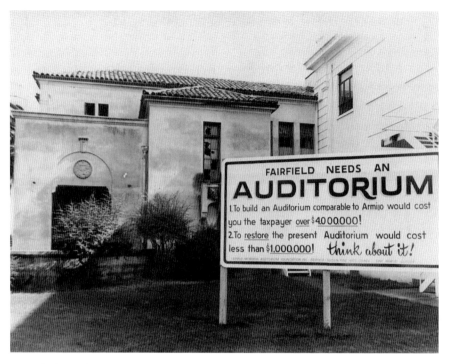

A sign in front of the old Armijo Auditorium in the 1970s that reflected the ultimately unsuccessful drive to save it. *Armijo Alumni Association.*

report said renovation would cost more than $1 million. The idea was floated to use a bond, but ultimately it was decided that the matter should be put to the people.

Proposition H, a property tax to pay for the renovations, was voted on in a June 8, 1976 special election. Fairfielders' professed love of the arts unceremoniously met their wallets at the polls, and there was no drama in the verdict: 70 percent were opposed, 30 percent were in favor.

The auditorium sat on death row for almost a decade until a last-ditch effort to have it declared a historical monument failed. In September 1984, the county gave renovation proponents six months to raise the needed funds to save the building, and they failed.

The Armijo Auditorium was demolished by wrecking ball on October 12, 1985.

Though the Armijo Auditorium was gone, arts groups continued to perform throughout the 1970s and '80s, often using the community center with its subpar acoustics.

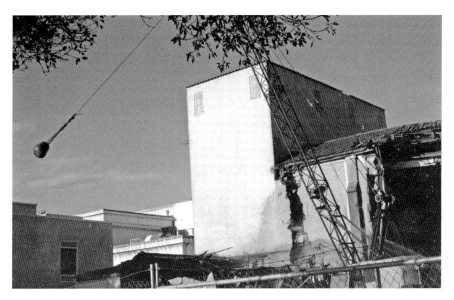

The demolition of the Armijo Auditorium by wrecking ball on October 12, 1985. *Tim Farmer collection.*

The plaque that was placed in the Fairfield Center for Creative Arts, now the Downtown Theatre, by the Armijo Memorial Auditorium Foundation Incorporated. *Tony Wade.*

In 1986, the city ordered yet another feasibility study, this one to build a cultural arts center. The Fairfield Center for Creative Arts, costing $7.2 million, opened on October 4, 1990.

In answer to the question by William Dean and others about what became of the Armijo Memorial Auditorium Foundation, Incorporated funds, in December 1988, Gojkovich donated the balance, $22,000, to the Fairfield Center for Creative Arts construction project with the caveat that a plaque be placed near the main stairwell where the balcony meets the lobby.

The plaque reads: "The lighting on this stairway is dedicated in honor of the contributors to the Armijo Memorial Auditorium Foundation, whose aspirations, dreams and fundraising efforts for a performing art theatre spanned many generations."

IRVING SCIBLE: FAIRFIELD'S FAMED LITTLE PERSON HAS LIVED A BIG LIFE

Growing up in Fairfield was not always easy for four-foot, five-inch Irving Scible Jr. While he was mostly treated with respect, there were still bullies who picked on him. One of his other problems was finding clothes that fit.

"I could find shirts and shoes and socks, but not pants," Scible said. "I went shopping at the Hilltop Mall with some friends back when shorts started to get longer. What were long shorts for my friends, were off-the-rack long pants for me."

Scible was born at Travis Air Force Base in 1958 with achondroplasia, a common form of dwarfism. His parents naturally had questions about how their son could fit into society. Their fears were eased a bit, however, as they had already had experience with another little person—the accepted term today—named Ellis Harper.

"It made it easier for my mom and dad because he got them in touch with the Little People of America," Scible said.

Founded in 1957 by actor Billy Barty (*Under the Rainbow*), the Little People of America's mission is to improve the quality of life for people with dwarfism. "Billy Barty and I became good friends. Like a lot of organizations, what it really does is show you that you are not alone," Scible said.

Jobs that Scible held included working in the *Daily Republic* press room and at Bonser's gas station. Fairfield was smaller then, and most everyone knew each other.

"I remember one day walking downtown during Easter vacation and Joe Lozano [original owner of Joe's Buffet] didn't know I was on break and called my mom. 'Did you know Irving is downtown?'" Scible said. "I grew up with more than one set of parents."

The very day he got his driver's license, Scible experienced something that later happened to him on a routine basis. "I used to have a four-wheel drive Ford pickup, and the first day I got my driver's license, I drove down Texas Street. A cop saw me and pulled me over," Scible said. "When he came to my window he said 'Irving, I just have to see how you're driving this thing!' "

Scible explained and demonstrated the special pedal extenders he used to drive, but other officers had to see it for themselves.

Scible's aforementioned friendship with Billy Barty led to his being cast in motion pictures and meeting other famous people. It all started at the now-closed Baskin-Robbins that used to be on North Texas Street.

"Max Baer Jr. [*The Beverly Hillbillies*] was filming *The McCullochs* locally and I was in Baskin-Robbins with my friends and some guy asked me if I wanted to be in a movie," Scible said. "I said 'Yeah, right,' then the guy dashed out and came back with Max Baer."

Another little person in the film, Billy Curtis (*The Wizard of Oz* and Mayor McCheese in McDonald's commercials), had to go to Los Angeles. Scible filled in but got no movie credit in the film.

In the mid-1980s, *Star Wars* filmmaker George Lucas produced two made-for-TV movies, ostensibly for his daughters, featuring the teddy bear–like Ewoks, who are featured in his 1983 movie *Return of the Jedi*. Scible's connection with Billy Barty and Billy Curtis got his foot in the door, and soon, he was an Ewok.

The film that Scible was in, *Ewoks: The Battle for Endor*, was the sequel to the 1984 feature *Caravan of Courage: An Ewok Adventure*.

"My most prominent scene is when we were on a hill knocking down logs on top of the marauders [the film's villains]," Scible said. "In another scene, when they blow up a wall and an Ewok covers his eyes, that's me."

Scible enjoyed the three months he spent making the film and met stars Wilford Brimley, Johnny Weissmuller Jr. (whose father played Tarzan in movies) and little-person actor Tony Cox. "The most impressive thing at the end of filming was when George Lucas remembered my name and we had only talked once," Scible said.

Ewoks: The Battle for Endor premiered as an ABC-TV special on November 24, 1985. Scible had a special screening with friends at Chuck E. Cheese's. The film is now available on YouTube.

Famed Fairfield little person Irving Scible with Michael Jackson at a barbecue. *Irving Scible.*

Other celebrities Scible has met include Jerry Lewis, Lorenzo Lamas, Ed McMahon and, at a George Lucas Fourth of July barbecue, Michael Jackson.

EUCALYPTUS RECORDS AND TAPES

Eucalyptus Records and Tapes was started in the early '70s by brothers Lewis and Orville Lambert. They came up with the catchy branding name, which evoked woodsy earthiness, and reinforced it by storing their albums in wooden fruit crates. The name fits on different levels, however, because the brothers come from a family with deep roots in Solano County.

The first Lamberts came to Suisun Valley in the 1840s, before the gold rush, and one of Orville and Lewis's ancestors donated the land for Suisun Valley School that is still located on…Lambert Road. The brothers graduated from the school before moving on to Armijo High. Their old family home is now the iconic Blue Victorian Winery on Suisun Valley Road.

The brothers had no experience in business but learned quickly through trial and error. Their first error was opening up downtown in the Country Corner Shopping Center next to a bar called the Peanut Patch. The brothers realized that their original location hindered their business, so in 1974, they moved to the unusual-shaped building at 2260 North Texas Street, near the skating rink that began as Dari-Delite a decade earlier.

"It allowed us to sell records downstairs and have our central office upstairs. We then opened stores in Vallejo, Napa and Davis. People knew us mainly by word-of-mouth," Orville Lambert said. "We opened a store in downtown Reno that just exploded. It did more business than the other four combined."

Stores in South Lake Tahoe, Yuba City and Sparks, Nevada, followed. Orville had a friend who knew Portland Trailblazers center Bill Walton, and the hoopster stopped by the store on North Texas Street—almost hitting his head on the ceiling—and bought a bunch of cassette tapes. That eventually led to the Lamberts opening up a store in Washington, which also became successful.

In 1976, the Fairfield store moved yet again, this time to the 7,200-square-foot building that Pinkerton Hardware once occupied.

Former Fairfield resident Darrell Anderson worked for Eucalyptus for four years and become a manager at eighteen. "The great part about

Left: The original location of Eucalyptus Records and Tapes in the Country Corner Shopping Center. *1972 Armijo High yearbook.*

Opposite: The old Pinkerton hardware building on North Texas Street. It became the third location of Fairfield's Eucalyptus Records and Tapes. *1968 Armijo High yearbook.*

working there was we didn't have to pay for records." Anderson said. "The beauty of working for an independent like that was they were as interested in the music as I was. So they would go to a one-stop place and buy everything that was released that week. We would dump it into a new release bin and then crack open whatever we felt like and play it in the store. It was pretty damn awesome."

To dig out a retail niche, Eucalyptus focused on underserved demographics.

"The big guys were into white rock and roll, but a lot of the airmen stationed at Travis Air Force Base were African American. We were very attuned to up-and-coming soul artists and would stock and play them in our stores. People would walk in and say 'Who's that?' We'd say 'Tower of Power' or 'Millie Jackson.' That set us apart," Lewis Lambert said. "The difference was we had a culture, a lifestyle. We operated in a different atmosphere that was much more agreeable to people. Part of any success as a business is the relationship between the owner and the employees. I hired some great

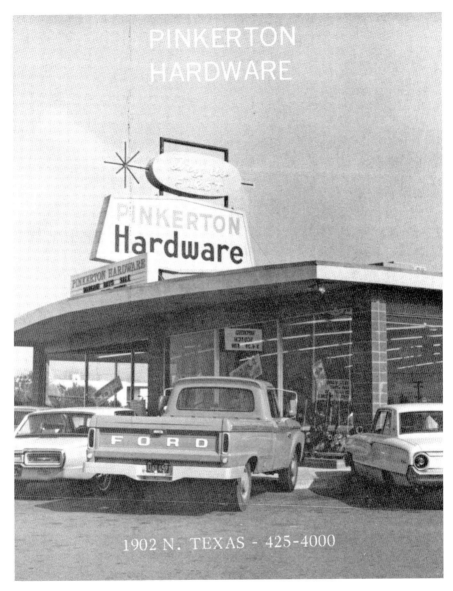

PINKERTON HARDWARE

1902 N. TEXAS - 425-4000

people. We worked together, partied together, went to concerts together. It was tough, man!"

In the movie *High Fidelity*, John Cusack's character runs a record store and refers to his two employees as music snobs. Darrell Anderson can relate. "Oh, we absolutely were snobs and I still am," Anderson said. "It's not just about taste; there is good and there is bad. We'd have guys who weren't real music fans buy a Fleetwood Mac record because their

The interior of Eucalyptus Records and Tapes in the old Pinkerton Hardware building. *1977 Armijo High yearbook.*

girlfriend liked it and we were merciless. I didn't hire anybody who I never saw in the store before."

Besides music, Eucalyptus also sold "smoking accessories." Sharon Lopez was a naive twelve-year-old who once wanted to buy one of their pretty "vases" for her mother. She says she can still hear the salesperson laughing.

Eventually, the Lamberts realized they'd overextended themselves. Paul Pennington, a business manager at Santa Cruz–based Odyssey Records, was brought in, and he eventually bought the business in 1978. First Orville and then Lewis moved to Colorado, and they formed Independent Records that year.

"The credit managers of every record label would meet every so often and determine which record retailers and distributors were a good risk to receive records and tapes on credit. They were the real power brokers in the business. They told me Eucalyptus needed help," Pennington said. "Orville and Lewis had created a fantastic record chain and they wanted to be like the big guys. But it took $50,000 just to outfit a new store and then you needed to build up a record inventory of about a million dollars."

One of the things that Pennington recognized right away at the Solano County stores was the incredible creativity of the staff. "Fairfield was loaded with brilliant artists. They would create displays inside the store using album

Fairfield Eucalyptus Records and Tapes manager and self-described music snob Darrell Anderson working the BASS ticket booth in the store. *1977 Armijo High yearbook.*

covers, and the industry loved them. Record company labels would take pictures of what the creative teams in Fairfield made and then pay people to travel all over the United States and replicate them," Pennington said. "They had merchandising contests, and we won them all. We won a Styx van, and Donny and Marie Osmond gave us a car."

Pennington was a rising star in the business; a 1979 newspaper article was titled "The Rags-to-Riches-Hit-Maker."

Eucalyptus Records and Tapes folded in 1985. One thing that has survived besides memories is the nickname that industry insiders like Solano County concert producer Jeff Trager, who knew Pennington when Trager worked as a record promoter, called him: "The Shah."

"I had a whole lot of fun, and it really all started with Lewis and Orville's record store," Pennington said.

FRESH MEMORIES OF HOLLAND DAIRY DRIVE-IN

While drive-thru fast-food places are now ubiquitous, back in the 1950s and '60s, the trend was drive-ins, where patrons either parked and ate in their cars or went inside to dine. Fairfield had C&K Drive-In, Foster's Freeze, A&W, Sid's, Hi-Fi and others.

Ironically, the only place you could actually drive through around that time didn't sell fast food at all, but "slow food" staples such as eggs, milk and bread. The double irony is that it was called a drive-in, namely, Holland Dairy Drive-In, which used to be located at 140 East Travis Boulevard.

Cornelis "Cor" Van Diemen was born in Holland in 1927 and immigrated to the United States in 1951. He worked for dairies in Sacramento and Lodi before opening his own business in Fairfield with his brother Nick. The unique feature of having an open-air drive-thru service for his goods—in effect an extremely convenient convenience store—was an immediate local hit.

Holland Dairy's grand opening was on December 11–13, 1959. Specials included a gallon of milk for ninety-one cents, farm-fresh grade AA eggs for forty-five cents a dozen and free popsicles for the kids.

"We had milk brought in three times a week from Lodi. Business took off and I advertised specials weekly in the local newspaper [then the *Solano Republican*]," Van Diemen said. "We were open seven days a week, 9:00 a.m. to 9:00 p.m., and only closed on major holidays."

The Van Diemens processed the raw milk on-site, pasteurizing and homogenizing it, and made whipping cream, half-and-half, chocolate milk and other products. Holland Dairy brought milk in glass jars to locals via their home delivery service and sold milk to every school in the county. Van Diemen's children, including his daughters Joyce Dolloff and Patrice Fiser, worked there, each starting when they were about fourteen.

"My uncle Nick was in charge of pasteurizing, homogenizing and bottling, and my dad handled the store part. Sunday was the only day Dad took off so

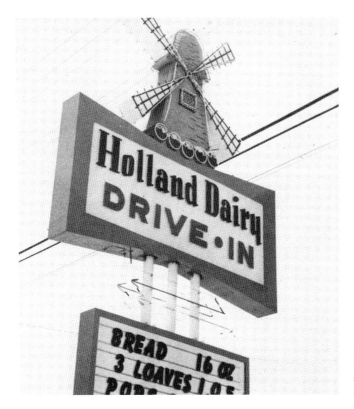

Holland Dairy
Drive-In's iconic
sign. *1977 Armijo
High yearbook.*

we could spend it together as a family," Dolloff said. "You talked to people one-on-one, got to know regulars and had to keep moving to keep the cars going through. It was fun and never felt like work."

"We would walk to the car window, take the order, put it together, ring it up, then put it in their back seat or trunk. A mother with a few kids could get all of her bread, milk and eggs and not even have to get out of the car," Fiser said. "We worked after school until 9:00 p.m., then rode our bikes home with the cash register money. My sister counted the money every night and got the register ready for the next day."

The Van Diemens ran Holland Dairy for about twenty years, leased it to others and then sold it. It changed hands numerous times, became the Travis Dairy and, tragically, was the site of a senseless crime in 2011. Owner Ho Kim was killed in a burglary committed by juveniles.

Holland Dairy's bow tie–shaped sign topped with a windmill became an iconic Fairfield image, and old photos of it often elicit remembrances of happy times from locals.

Michael O'Brien: Cold, fresh, chocolate milk in a bottle—delicious.

Kathleen Hardy Stoops: We lived around the corner from Holland Dairy in the '70s. My kids walked there all the time for treats and milk—and never brought back the change.

Sam Vineyard: I remember when they used to deliver milk to our porch in the glass bottles with the cardboard tops. When you first opened them, you could hear the vacuum pop!

Kurt Vineyard: Cor Van Diemen gave me my first real job right out of high school when minimum wage was $1.65 an hour. He also gave me a $200 advance so I could get my first apartment! Great family!

Tamara Beck Watson: My family would load up in the car (late '50s, early '60s) on payday and head to Holland Dairy. They would always ask if we needed ice cream. Some weeks, pay was scarce and Dad would say, "Not this time." They always, always, handed us kids a piece of candy or a treat. They were really good people.

INTERLUDE: THE GREAT FARRAH-FAWCETT-IS-IN-FAIRFIELD-FAKE-OUT OF 1977

I can't remember which class I was in when I first heard the rumor. It may have been Ms. Sorenson's social studies class or Mr. Powers's algebra course, but it hit like a bolt of lightning.

Farrah Fawcett-Majors was coming to Fairfield.

It was Friday, March 18, 1977, and I was thirteen years old.

Now, why a celebrity who was then supernova hot would visit a city of fewer than fifty-eight thousand people that didn't even have a regional mall to put it on the map was a question easily dismissed.

Hope mixed with hormones beats the snot outta logic.

Farrah Fawcett-Majors exploded onto the pop-culture scene when the TV show *Charlies Angels* debuted in September of the previous year. It was about three attractive private detectives (Farrah, along with Kate Jackson and Jaclyn Smith) who solved crimes for a boss named Charlie who was always unseen and only heard on a speakerphone.

Then there was Farrah's poster.

The iconic shot of beaming, blond-maned Farrah in a red swimsuit sold more than twenty million copies, including one that my ten-year-old brother, Kelvin, somehow got away with hanging on his bedroom wall and not having my mom take it down.

Farrah was a sex symbol and a TV star and, to top it off, was married to bionic Lee Majors, "The Six-Million-Dollar Man."

The rumor was that Farrah would be at the Kmart parking lot at 1:00 p.m. I wasn't one to cut school, but my last two classes of the day after lunch were Ms. Murray's photography class, which I did not like, and Mr. Boitano's woodworking class, which I was terrible at.

My friend Mike and I floated the idea of writing notes "from our parents," similar to the ones we'd used successfully to purchase cigarettes at EZ Mart. The sudden appearance of notes for doctor's appointments that we didn't present in first period might seem suspicious, though, so we decided to just make a break for it at lunchtime.

There were no fences around the campus then, so it wasn't that hard to sneak off. Our original plan was simply to walk west down East Tabor Avenue, take a right on North Texas Street where it dead-ended and take the straight shot to Kmart.

But Fairfield Police might see us and wonder what two kids who should be in school were doing. In fact, our plan was almost derailed at the beginning when we had to hide from a FPD cruiser by quickly scrambling down the embankment of the creek by Sunset Avenue where we had caught insects in jars for Mr. Gaut's biology class.

We then decided to take a more circuitous route through the residential neighborhoods. Our forty-minute trek was not exactly filled with the same kind of adventures the friends in *Stand By Me* encountered on their excursion to see a dead body, but we did get chased by a German Shepherd that had gotten loose and found a Kennedy half dollar, which we used to buy fries at McDonald's.

Before we even arrived at the Kmart parking lot, we could see the huge crowd of people who'd gathered there. As we drew closer, Mike and I saw numerous Grange students present and breathed a little easier about our decision to cut.

Cheers welled up to our left, and we strained to see over the throng. The crowd noise came progressively closer, as if they were doing the wave, and we finally saw what everyone was cheering about.

It was a team of Budweiser Clydesdales. They were there to celebrate the opening of the new Budweiser brewery located near Interstate 80.

Farrah Fawcett-Majors was not there.

How had such a rumor in the days before social media and hashtags spread so quickly all over Fairfield?

Could it have been someone innocently overhearing someone else talk about the elegant feathered hair that the Clydesdales famously have covering their hooves and thought they heard something about Farrah's trademark feathered hairdo?

Not likely. I suspected it was a stunt dreamed up and executed by Budweiser public relations folks.

I felt duped, used and angry.

Not angry enough to not tune into *Charlie's Angels* the following Wednesday night, though.

LET'S EAT!

*T*here is a world of difference between a high falutin', snooty foodie and someone who just likes to get their grub on. Without doing any kind of survey or poll, I think I can quite comfortably claim that most Fairfielders, for decades, have fallen into the latter category. And they are cool with that.

In Praise of Dave's Giant Hamburgers

In 1963, former San Francisco accountant Dave Heim bought the restaurant at 1055 North Texas Street that had been Ronny's Drive-In in 1959, the Drive-Inn in 1961 and ¼ lb Big Burgers in 1962. It has been Dave's Giant Hamburgers ever since.

Sorta.

In the early 1970s, it was Dave's Giant Hamburger & Spudnut Shop (more on that later), and for at least six years in the 1980s it was cleverly named Dave's Giant Heimburgers. A sequel, Dave's Giant Cheeseburgers, opened in Vacaville in 1983, but it was sold in 1989 to pay off an IRS debt.

As much as it is a Fairfield institution, there are actually some locals who refuse to bow down to its greatness. The most common complaint is that Dave's does not serve French fries.

This one is an underhand, slow-pitched softball that is oh so easy to knock right outta the park.

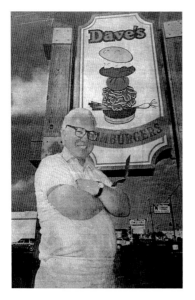

Dave's Giant Hamburger owner Dave Heim in front of his iconic Fairfield restaurant. *Fairfield Civic Center Library microfilm.*

Yes, it is true that Dave's has no French fries. Similarly, Superman doesn't need a sidekick, either.

Dave's needs no fries. Dave's transcends fries. What they "lack" in fries, they more than make up for with fresh pie. Plus, numerous Fairfield burger joints from the past—Hi-Fi, Sid's, Beamer's, A&W, Fosters Freeze and Sno-Man—all served fries and are now gone! Dave's rightly realized that French fries evidently are the kiss of business death.

What follows is some completely nonhyperbolic praise for Dave's.

In case of nuclear attack, you can duck and cover behind a Dave's giant hamburger.

Scientists recently confirmed that the food second only to breast milk in optimal nutrition for newborns is a Dave's burger pureed in a blender.

The all-star band featuring Dave Matthews, the Foo Fighters' Dave Grohl, Megadeth's Dave Mustaine and Pink Floyd's Dave Gilmour are headlining this year's Dave'sFest, a rock 'n' roll tribute to the Fairfield burger joint.

The Berlin Wall was torn down primarily because people wanted to come to Fairfield and get a Dave's burger.

There was going to be a huge balloon of a Dave's Giant Burger in the Macy's Thanksgiving Day Parade, but inflatable Garfield ate it.

A Dave's burger once beat up Chuck Norris.

The songs "You Are So Beautiful" and "I Can't Stop Loving You" were actually love odes to Dave's Burgers, and Billy Joel wrote "Just the Way You Are" about how Dave's needs no accompanying fries.

If Luke Skywalker hadn't beaten them to it, Dave's Giant Hamburgers would have brought balance to the Force.

Several people who grew up loving Dave's actually named their offspring after the beloved eatery, which is why, according to the latest census, Fairfield, California, has the largest concentration of people named "Burger" in the entire country.

Has Dave's Changed?

Dave Heim ran his business until his death in 2006, and now his daughter Lesa Gonzalez manages the day-to-day operations. She set the record straight on a number of items.

Did Dave's Ever Sell Fries?

The short answer is "yes," and the reasons why they were discontinued are varied, but Gonzalez distilled it down to one thing. "A lot of Armijo students or neighborhood customers would just buy fries and my dad needed to sell burgers. So the main reason was economic. Sorry it's not very exciting, but it's the truth," Gonzalez said.

When new customers are surprised to find there are no fries, Gonzalez puts a positive spin on it. "I just tell people that everything we sell is fresh. Except for In-N-Out, burger places with fries use frozen ones. We don't even have a freezer here."

Dave's Sold Spudnuts? What's a Spudnut?

Spudnuts were doughnuts created from potato-based flour. They were invented by two brothers from Utah in 1940, and Spudnut Shops became a booming franchise. Both Vallejo and Vacaville had Spudnut Shops. In the late 1960s, it was the largest doughnut franchise in the United States.

Dave Heim got in on the act, and a 1970 *Daily Republic* advertisement reads, "Dave's Giant Hamburger & Spudnut Shop."

In 1971, Winchell's Donuts opened a new shop less than half a mile from Dave's. Dave saw the writing on the wall and got out of the Spudnut business.

Have the Burgers Changed?

Some old-timers say that Dave's is not like it used to be, so I asked Gonzalez about a variety of different things. Here are her lightning-round answers.

The meat: "It's fresh, it's the same blend and, as a matter of fact, it's the same butcher for over thirty years."

The buns: "We've used the same buns for fifty-five years."

The cheese: "We use Kraft American Cheese—the same since day one."

The size: "Our burgers are one-third pound, the exact same size they've always been. Nowadays people get doubles and triples."

The special sauce: "We use Kraft salad dressing. It's not Miracle Whip. That's what makes them distinctive. It's just more practical. My dad never used mayonnaise because you can't leave it sitting out."

The pies: "We never made them here. My dad used to have them delivered by St. Francis Pie Company in Oakland, and they went out of business about twenty years ago. It was a fun day when the pies would be delivered—you could pick from racks and racks. He started getting them from Rosanna's European Delights for the last fifteen years, and we still do."

JOE'S BUFFET: ROAST BEEF HEAVEN

For many Solano County locals, the mere mention of two words can make their mouths water like Pavlov's dogs. Those two words are *Joe's Buffet*.

Add five more words, *au jus roast beef sandwich*, and most will be in full drool mode.

Saeb and Nabiha Ziadeh have owned the landmark eatery for more than thirty years, and Saeb is often referred to as "Joe." But the original owners were Joe and Isabel Lozano.

At the business's grand opening, on February 27, 1953, it was called the Fairfield Delicatessen. The Lozanos' son, Bob, worked there throughout high school and college. Their daughter, Eleanor Lozano Cullum, helped with bookkeeping.

The shop was located, as it is today, at 834 Texas Street, but when it opened, the Lozanos shared the space with the Fairfield Meat Market, owned by Bud and Marge Freitas. When customers walked in, the meat market was on the left and the deli was on the right.

The Fairfield Delicatessen's original fare included homemade salads, seafood, roasted meats, imported and domestic cheese, enchiladas, cold meats, party snacks and ice cream.

"My mom made all the salads from scratch, and her potato salad was phenomenal. Then my dad got the idea to sell pies, and my poor mother had to make all these lemon meringue pies," Eleanor Lozano Cullum said. "Every six months, he came up with something else. He tried selling tacos way before Taco Bell or anything like that. He'd pick up homemade tortillas from a guy in Vallejo because they didn't sell them in stores like they do now."

Joe's Buffet, as interpreted by artist Donna Covey. *Donna Covey.*

"When we opened, the population in Fairfield wasn't that big, so it was a struggle at first," Bob Lozano said. "It was basically a farming community, so we started trying new things. We sold fresh fish that we would get from Oakland and that was new to Fairfield then. I remember seeing live crabs crawling around the kitchen floor. I became an expert at cleaning crabs."

The pastrami-on-rye sandwich the Fairfield Delicatessen served was a hit with military transplants from the East Coast, especially New Yorkers. The potato salad was served right on the sandwiches and reminded them of ones they enjoyed back home.

The restaurant expanded when the Fairfield Meat Market closed. The dining area that used to feature photos of rock 'n' roll icons was at that time Freitas Toggery and was only added much later.

The delicatessen evolved into Joe's Buffet because Joe Lozano responded to customers. "My dad had a shelf with really good French bread and people would ask him to make them a sandwich using a French roll and our good quality cold cuts," Bob Lozano said. "They would stand at the counter and eat. That went on for a few years until Dad added a counter with five or six stools so they could sit down."

Soon, lunch lines snaked out of the door onto the sidewalk. In addition to Armijo High School students, many local political movers and shakers hung out there as well.

Many recall Joe Lozano as quite a character. "Crotchety" is a common descriptor. Bob Lozano describes him as sometimes being a real-life "Soup Nazi" like the fictional one on *Seinfeld*.

"If a customer wanted something unusual, he would tell them, 'No, you can't have that!' Or if someone wanted cheese on their roast beef, he would tell them, 'You don't put cheese on roast beef sandwiches....Next!'"

But there were other sides to Joe as well.

Bob Lozano was a member of the Pizzarino boys, who were Armijo High jocks/pranksters during the 1950s. The night before football games, Joe Lozano would host a steak dinner for the entire team.

He would also help out local kids, who would today be deemed "at-risk," through a work-experience program at Armijo. "One young man came back years later and thanked my dad for pointing him in the right direction. I believe he became a city manager in some city down south," Bob Lozano said. "At closing time, sometimes the poorer people in town would come in and he would feed them for free. He was a great example for me."

Local folks reminisced about Joe's Buffet:

Suzan McKenzie: I worked down the street at Adamo Music and used to go to Joe's five days a week for a salami sandwich. After the first week, although there was always a line out the door, when he would see me coming, he would say, "Oh there's my Salami Queen." Made me feel special.

Casey Coppock: My Dad would take me there. Joe hung my first deer in his meat locker and butchered it.

Jackie Taylor: In 1971, when I was eighteen years old, I had been in an accident earlier in the summer and had a cast on my left arm. I was still kind of banged up and had lost a lot of weight. I walked into Joe's with four quarters—the roast beef sandwich was one dollar back then. He took one look at me and started loading up my plate with food. I told him I only had a dollar, he waved me off and told me to eat everything on my plate then went to the next customer and didn't even charge me the dollar! I will never forget his kindness.

Bill Pinkerton: It was so simple yet so delicious. When you came in you better be ready to order. Joe did well in Fairfield, and I would have put him against the best in Chicago and Philly—two places that love their sandwiches.

Tanja Duncan: I was introduced to Joe's in 1989 by my now husband and his father. I have been an addict ever since. I can't praise his food or the man himself, enough. His wife and I were pregnant around the same time, and he always gave me extra potato salad and pepperoncini, which I craved endlessly. When I told him my son ended up weighing eight pounds, five ounces at birth, his eyes got real big, and then with that warm smile of his, he said, "It was the extra potato salad, I'll bet." From then on, my son was referred to as Joe's Potato Salad Baby.

Fairfield Fast Food Timeline

The following list of Fairfield fast-food restaurants isn't meant to be exhaustive, but just to give you a…er, taste of the quick cuisine locals have dined on over the decades. While there were local restaurants around before these that sold fast-food items like hamburgers and fries, fast-food establishments are defined here, for the most part, as eateries that featured walk-up, drive-in and/or drive-thru service. Pizza joints were not included. Most of the dates are verified, but some had to be guesstimates, as it ain't like there's some old-school database for this stuff.

1951—Sno-White: 530 Union Avenue

The Armijo High School yearbook *La Mezcla* started including advertisements from local businesses in 1952, and the only fast-food place listed was the Sno-White on Union Avenue (which later became Sno-Man).

Jean Taylor Hamilton: They had the *best* soft-serve ice cream cones that I'd get whenever I could scrounge up a spare quarter! On really hot days I'd be licking the melting deliciousness before it could reach my hand as I walked from Armijo to Suisun, sometimes waiting for the trains to go by before crossing the tracks to head for home (long before they built the overpass)!

Above: Sno-White, which later became Sno-Man and was located on Union Avenue. *Armijo Alumni Association.*

Left: Sid's Drive-In, which used to be near the corner of Travis Boulevard and North Texas Street. *1966 Armijo High yearbook.*

1954—Sid's Drive-in: 1513 North Texas Street (Corner of Travis Boulevard)

Gail Kneezle-Reed: I walked past Sid's every school day on my way to/ from Bransford Elementary from 1959 to 1961. I wanted to be a teenager so I could hang out there! By the time I was a teenager, Sid's was gone.

1955—Hi-Fi Drive-In:
"Home of 24-Cent Steakburgers": 1513 West Texas Street

Verna Lawrence Cadorin: Hi-Fi was my first job after cutting fruit. I got paid $1.35 per hour. On Sunday we sold six burgers for $1.00.

1959—A&W Drive-In: 100 East Tabor Avenue

Papa, Mama or Baby Burger in a basket (fries) with a frosty mug of root beer delivered to your car. Mmmmmmm.

Rick Permenter: I remember the train tracks that ran behind A&W. When I was little, my brother and I would walk there and catch lizards and then go to A&W and get a root beer.

1959—Foster's "Old-Fashion" Freeze: 1430 North Texas Street

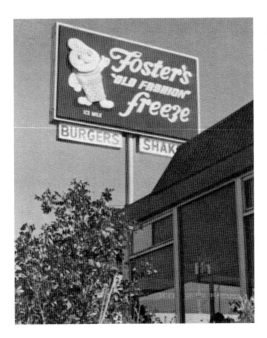

Leah Ramos-Amiccuci: We would Jazzercise, then go there to get fries and a cone and dip the fries into the ice cream. We were young and dumb.

Foster's "Old-Fashion" Freeze, which used to be located on North Texas Street. *1980 Armijo High yearbook.*

1959—Ronny's Drive-In: 1055 North Texas Street

Ronny's had a great location, close to Armijo, but didn't last anywhere near as long as its famous successor.

1963—Dave's Giant Hamburger: 1055 North Texas Street

Dave's took over the spot where Ronny's used to be and is still there.

Laura Deal: When I was a student at Armijo High School, I had a teacher who loved Dave's milkshakes as much as I did. If I finished my work early, she would give me a hall pass. She would write "metaphysical observations" on my pass and send me to Dave's with enough money to buy us both milkshakes!

Rick Williams: Dave always kept his secret spicy sauce hidden behind the counter, and if you knew about it he would put it on before he cooked the burger and on the bun if you asked for it. Not many know about it—it was kinda like the In-N-Out Burger secret menu.

1964—Dari-Delite: 2260 North Texas Street

This was in that odd-shaped building that was a vacuum store, Eucalyptus Records and is now the Latino Beauty Salon. It became a different fast-food place, Crunchy's, in 1972.

Shari Boulden: I worked at Dari-Delite for a few months in 1969–1970. They featured quantity (ten burgers for one dollar), not necessarily quality. The Fairfield High wrestling team used to starve through weigh-in, go to Dari-Delite and buy hamburgers and fries by the gross. A bunch usually ended up at my house to eat the burgers and play Bid Whist the night before a meet. Fun times.

The Mexican fast-food restaurant Jumpin' Bean opened up six months before Fairfield's first Taco Bell. *1969 Fairfield High yearbook.*

1968—Jumpin' Bean: 2101 North Texas Street

This Mexican fast-food restaurant opened six months before Taco Bell. Later, General Fu Man Chu, that offered the strange FU-Burger that had chow mein on it, was at that location.

Doug Jensen: The name Jumpin' Bean is weird for a restaurant, because Mexican jumping beans jump due to a small worm inside!

1968—Kentucky Fried Chicken: 2277 North Texas Street

Colonel Sanders himself cut the ribbon at the grand opening.

1968—Taco Bell: 1661 North Texas Street

Carl Lamera: On the weekends we'd visit my high school buddy Jeff, who was a night manager at Taco Bell. Once, another buddy of ours was a bit—how should I say—under the influence of festive beverages. He ordered a burrito with no onions. He ranted about how he hated green onions, to the point that he was downright obnoxious. Jeff loaded scoop after scoop of green onions into his burrito. We watched and laughed as our onion-hating friend chowed down on the burrito like it was the best meal he ever had.

Moral(s) to the story. One, be nice, even when you're sloshed. Two, don't let an inebriated person into your car who has just downed a green onion burrito unless you want to clean up green puke from your car mat.

1970—Jack in the Box: 1980 North Texas Street

Fun facts: Jack was a super-creepy-looking clown then, and one of the food items offered was shrimp.

1970—McDonald's: 2212 North Texas Street

Linda Ames: In the '70s, it was a bummer to see my friends come in while they were cruising when I had to work until midnight. But we'd go out after work and find some trouble to get into. Like driving to the lake to drink. Don't tell my mom.

Tracy Vest: My biggest pet peeve when I worked at McDonald's was people who ordered unsalted fries (so they could have them fresh, not realizing that at 12:30 p.m., the possibility of getting stale fries was nil). Then they would ask for salt. I always pierced the salt packet before putting it into their bag. I've always been kinda passive aggressive.

1970—General Fu Man Chu: 2101 North Texas Street

General Fu Man Chu featured "Chinese food with an American twist." It was only in business around 1970 and 1971, and a microfilm *Daily Republic* ad touted it as "the ONLY place in the world where you can try a FU-Burger." Rarity doesn't always translate to quality, however.

Jim Osada: I worked at Baskin-Robbins next door at the time and ate at General Fu Man Chu frequently. A FU-Burger was terrible chow mein wedged between two hamburger buns. It also smelled bad. Their spring rolls were good, though. They were filled with grease, which helped them slide down your throat. I always had an ice cream chaser after eating there.

The Jack in the Box restaurant on North Texas Street in the early 1970s. *Tony Wade.*

A 1970 ad for the General Fu Man Chu restaurant, which used to be on North Texas Street. *Fairfield Civic Center Library Microfilm.*

1970—Johanne's Hot Dogs: 1708 West Texas Street

In its grand-opening write-up, Johanne's products were described as "savory jumbo all-meat hot dogs served with juicy red tomato wedges, crisp tangy slices of onion, a perfect dab of spicy relish and snappy mustard."

Scott Seymore: The first hot dog I had there was a free one for hitting a home run in Little League in 1974.

1971—Crunchy's: 2260 North Texas Street

This was in the odd-shaped building that was first Dari-Delite and later became, among other things, Eucalyptus Records and Tapes, a vacuum store, Heritage Realtors and now the Latino Beauty Salon.

1971—Winchell's Donut House: 760 North Texas Street

The original Fairfield Winchell's opened near Travis Air Force Base in 1959. This new one became popular with Armijo High School students and—not stereotyping, just facts—Fairfield police officers. Another one opened later in the Mission Village shopping center.

Tom McDowell: I worked at the one at Mission Village, became assistant manager at the one across from Armijo, then manager at the one outside of Travis's main gate!

1972—Vicki's Drive-In: 1470 Holiday Lane

Vicki Miller: My dad, Bernard Moore, who owned Moore Tractor Company, bought the tractor business in 1961 and owned all the property to the freeway. When it was all subdivided, there was only that little piece of ground left, so he decided to build a drive-in there. My mom ran it and served good food and generous portions (that's why we didn't make money), and we made lots of friends. It was an adventure for sure, but my mom was always a stay-at-home mom, and we didn't like her working, so we quit the business.

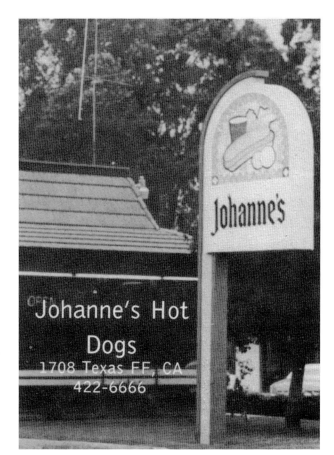

Right: Johanne's Hot Dogs, which was located across the street from Allan Witt Park. *1981 Armijo High yearbook.*

Below: The odd-shaped North Texas building that was Dari-Delite, Crunchy's, Eucalyptus Records and Tapes, a vacuum place and more. *1972 Armijo High yearbook.*

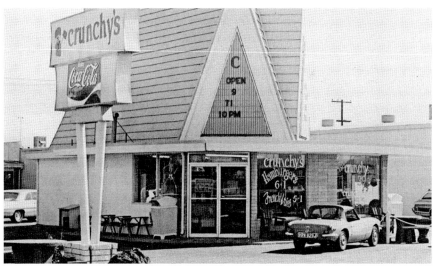

1973—Sno-Man Number 2: 1615 West Texas Street

You know a restaurant is popular when it has a sequel.

1974—Big John's Sub Shop: 1807 North Texas Street

Big John's featured twenty-one varieties of subs and asked that you order by number.

1976—Burger King: 2415 North Texas Street

Shelley Thurman: I met my husband at my job (Burger King). My car had broken down a few days before, so I asked a friend to pick me up. She was hanging out with him at the time, and they picked me up from work. We were married seven months later, and have been together for over thirty years now.

1976—Long John Silver's Seafood Shoppe: 2263 North Texas Street

One word: hushpuppies.

1977—Hamburgers Inc.: 3001 Travis Boulevard

Doris Bruestle: My first job. Raley's wasn't there yet. Geri Lane owned it, and he used to tell us—with his arms wide open—that someday, "this will all be Geri-Towne!" We thought he was *crazy*!

1978—Carl's Jr.: 2380 North Texas Street

Tony Wade: This was my first real job, and I loved doing kids' birthday parties, because I could wear my own clothes instead of the tacky, greasy uniform, and for games like musical chairs I'd crank AC/DC's "Back in Black" on my boom box in the dining area.

1978—Skipper's Seafood and Chowder House: 2285 North Texas Street

Yes, there were two fried fish places less than four hundred feet apart. Not quite as weird as the twin Denny's across town, but close.

1978—Wendy's: 2045 North Texas Street

More power to Wendy's fans, but burgers shouldn't be square.

1979—Church's Fried Chicken: 2370 North Texas Street

Evidently, Colonel Sanders won the Great Chicken War, as KFC survives and Church's surrendered years ago.

1979—Kermit's Hot Dogs: 2791 North Texas Street

Kermit's menu featured eighteen gourmet hot dogs, including an Italian pizza dog, chile relleno dog and a Hawaiian pineapple dog.

No frog's legs dog.

1979—You's Burgers: 1615 West Texas Street (later on Second Street)

Captain Don Yoo, Fairfield Fire Department: My parents worked sixteen-plus-hour days almost every day. Christmas and Thanksgiving were their only days off. That little fast-food joint kept us housed, fed and clothed for a huge part of my childhood and paid a chunk of my tuition to UC Santa Barbara. Many now-retired Fairfield Fire Department guys remember the Chuck Burgers, crinkle-cut fries and pinball machines. You's Burgers never made us rich, but we had everything we needed because of it.

1983—Beamers: 1430 North Texas Street

Tracy Harney: Beamers' thirty-nine-cent hamburgers were the bomb!

Terri Haskell Bradley: Yep! Best place to eat out for broke newlyweds!

INTERLUDE: MY DREAM OF AN OLD-SCHOOL FAIRFIELD FEAST

I stumbled across a vintage Red Top Dairy milk bottle at Rockville Park recently. I rubbed it on my shirt to read the label better, and suddenly there was a "poof!" accompanied by a puff of smoke.

A genie that kinda looked like the Waving Chief Solano Statue told me he would grant me one wish. I asked why not the customary three wishes, and he shrugged and replied, "Budget cuts."

I thought hard, then had it. "I want an old-school Fairfield feast featuring food from restaurants that don't exist anymore."

The genie did that *I Dream of Jeannie* blinking nod, coupled with a Samantha Stevens nose twitch, and suddenly I was seated before an enormous table. Several mini-me genies acted as silent but efficient servers.

The appetizers were Nut Tree pineapple chunks with the yummy marshmallow sauce. I didn't quibble about it being from Vacaville, I just dug in.

The meal started in earnest with Voici's house salad and fresh cheese bread. I then consumed two bowls of savory minestrone soup—one from Firehouse Deli and the other from the Old San Francisco Express.

Next, I wolfed down a stack of fluffy Sambo's pancakes smothered in buttah and warm maple syrup with a side of crispy bacon.

Then it got serious.

The Chinese portion of the meal featured sweet-and-sour pork from Eastern Café and a sampling of yumminess from Chinese smorgasbord Birdcage Wok. The genie frowned at my use of a fork instead of chopsticks, but that's how I roll.

An enormous platter of fried delicacies was next, from David's Fish and Chips, Skipper's and then Dick's Seafood Grotto. Loren's Fountain French fries were a special treat, as were the Howard Johnson's fried clams.

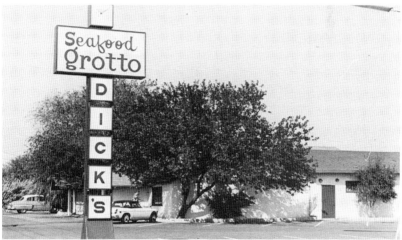

Top: Classic cars in front of Fairfield's swanky Voici restaurant in the 1970s. *Irving Scible*.

Bottom: Dick's Seafood Grotto, previously known as Dick's Restaurant and Dick's Fine Foods, on Pennsylvania Avenue. *1972 Armijo High yearbook*.

My hearty belch signaled the genie. "Bring on the burgers!"

The mini-me genies then brought in hamburgers ranging from Beamers' twenty-nine-cent ones to Hi-Fi burgers to an A&W Papa Burger in a basket coupled with a frosty mug of root beer. The Airline Café hamburger was very tasty, as was the Fosters Old-Fashion Freeze bacon cheeseburger.

But I especially loved the Sid's burger from Sid's Drive-In.

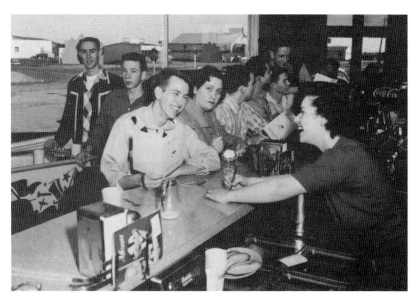

The interior of Sid's Drive-In, which used to be near the corner of Travis Boulevard and North Texas Street. *1955 Armijo High yearbook.*

My friend Nanciann Gregg had been a carhop for them and told me they used to cover the cooking burger and buns on the grill with a domed lid so the grease and grill smell penetrated the buns to delicious effect. She was right.

Speaking of grease, the next course was exquisite enchiladas from The Hut and tasty tacos from Dan & Ruth's. I declined to have a fried egg put on top of my enchiladas the way The Hut's ginormous cook ironically nicknamed Tiny used to do, but they were still delectable.

Pizza was next. Wow! As if hot, fresh offerings from Sham's, Rico's, Pietro's, Roscoe Capone's and Vittorio's weren't enough, they even served my favorite treat from Big John's Submarine Shop: its delicious pizza sub.

The chicken course included Muffin Treat's roasted chicken in a basket, samples from Chicken Delight and the legendary Smorga Bob's fried chicken that many people "liberated" from the old eatery in hidden Ziploc bags back in the day.

As I saw it was steak time next, I loosened my belt. I pulled the little plastic "well done" sign out of my Mr. Steak T-bone while breathing in the heavenly scent of my Happy Steak London Broil.

Left: Muffin Treat, across the street from the old Solano Drive-In on North Texas Street. *1976 Armijo High yearbook.*

Right: Smorga Bob's all-you-can-eat restaurant, which was located on West Texas Street across the street from Allan Witt Park. *1973 Armijo High yearbook.*

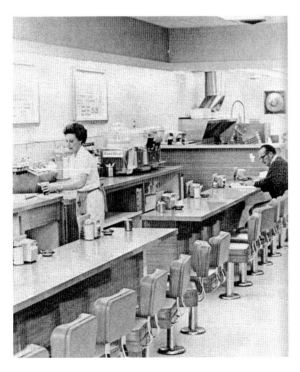

The interior of Flakey Cream Doughnuts, which was on Texas Street. *1972 Armijo High yearbook.*

Sisters Else Nakamura and Mary Minakata, co-owners of Baskin-Robbins, which used to be on North Texas Street. *1970 Armijo High yearbook.*

I finished up with Tony Roma's ribs and Lyon's cheddar-topped chili.

Totally stuffed, I would've declined dessert if I hadn't beheld it.

Flakey Cream and Winchell's doughnuts. Sno-Man soft-serve ice cream. Thrifty's double scoop cones. A hand-packed pint of Baskin-Robbins Pralines 'N Cream. And the pièce de résistance: glorious champagne cake from Johnson's Bakery.

I found room for it all.

I felt like I would explode and suddenly heard a weird, loud, rumbling sound like a rolling earthquake. The angry rumblings from my empty stomach were so loud they woke me from my feasting/genie dream.

I was ravenous.

Since I couldn't actually eat at the places I'd dreamed about—some remembered and some from before my time—I went to two old-school Fairfield restaurants where I can still get my grub on: Joe's Buffet for lunch and Dave's Giant Hamburgers for dinner.

Bon appétit!

FAIRFIELD ON FILM

The Good, the Bad, the Ugly and...
Well, the Dirty

THE McCULLOCHS

Max Baer Jr. became famous playing boneheaded behemoth Jethro Bodine on TV's *The Beverly Hillbillies*. When the series ended in 1971, he couldn't get work because he was typecast.

In 1974, Baer wrote, produced and starred in *Macon County Line*. In 1976, he made *Ode to Billie Joe*. Both generated exponential amounts of moolah from their initial investments.

Sandwiched between those two movies, however, was a 1975 Baer-produced picture called *The McCullochs*, with parts filmed in Solano County. Many locals were extras in the flick. When it premiered at the Americana II Theater on July 9, 1975, Fairfield mayor Manuel Campos and other dignitaries attended.

I watched *The McCullochs* for the first time with local longtimers Keith Hayes and Nanciann Gregg and followed the viewing with a rather scathing review in a *Daily Republic* column. On further viewings, it still isn't a good movie. For instance, it is supposedly set in 1949 Texas but looks and feels like 1970s California. But it has its moments.

Forrest Tucker, who played Sergeant Morgan O'Rourke in the TV show *F Troop*, starred in *The McCullochs*. A few of his costars were Incomprehensible Plot, Horrible Acting and Time Inconsistencies.

The cover of the soundtrack to the film *The McCullochs*, which was filmed partly in Fairfield. *Monstrous Movie Music.*

I arranged a screening at my church in 2013 for members of the "I Grew Up in Fairfield Too" Facebook group. I reached out to costars Max Baer and Julie Adams through Facebook, and the latter (who starred in 1954's classic *Creature from the Black Lagoon*) responded and answered some questions via email about the film.

Her son, Mitch Danton, was gracious enough to express-mail me goodies, including an autographed copy of Adams's book, *The Lucky Southern Star: Reflections from the Black Lagoon* (www.julieadams.biz), and an autographed CD of *The McCullochs* soundtrack by Academy Award–winning composer Ernest Gold.

The CD, produced in 2012, is a treasure-trove of information. In its sixteen-page liner notes, I discovered probably the most detailed info on the movie I have been able to find anywhere.

Whoever marketed *The McCullochs* ingeniously got paid to create an ad campaign for a film they obviously had not seen. It was marketed as an action movie (often still using the working title *The Wild McCullochs*) and, instead of focusing on the better-known actors, like Forrest Tucker and Julie Adams, they featured the younger, lesser-known actors. It was pitched as depicting how fun it was to be a freewheeling teen when your dad was rich.

Only, that is not what the film is about, as far as can be sussed out.

Actually, it was a bit ahead of its time in exploring the dysfunctional wealthy family dynamic that would later fuel TV shows such as *Dallas* and *Dynasty*.

Before the feature presentation at my church, locals who had been extras spoke. Longtime Fairfield actress and costume maker Betty McFadden said that Max Baer let it be known that they were welcome there, but if anyone called him "Jethro," they would be gone.

Minna Gross spoke of her late husband, U.S. Air Force pilot Major Philip Gross, who had an onscreen scene—as a pilot—and even had a line he said to one of the McCulloch boys (played by *My Three Sons* costar Don Grady): "You're property of the United States Air Force now—let's move it!" That scene got the biggest applause of the evening.

While the movie featured other recognizable actors, including another *My Three Sons* star, William Demarest (Uncle Charley), the audience was really there to see locals and locales. After the movie ended, I rewound and freeze-framed scenes of Mankas Corner, Rio Vista, the late Mr. Maben (a teacher at Armijo) and my former polling place coworker Rose Marie Galvan.

Just to wrap the film's mediocrity up with a bow, there's a scene in which one of the characters comes into the house angry, and Forrest Tucker's character asks him what is wrong.

I said, "He's probably mad that he's in this movie."

WITCHBOARD

Okay, for the record, *Witchboard*, the first feature film from 1973 Fairfield High School graduate Kevin S. Tenney, was filmed in Los Angeles, but it was set in Fairfield. His later project *Witchtrap* was actually filmed in Fairfield—specifically, at the Stonedene Mansion across the street from Solano Community College.

Witchboard debuted on March 13, 1987—Friday the 13th—in Fairfield theaters (and in more than one thousand more nationwide), and it became "The Lil' Supernatural Horror Film That Could."

Tenney cut his cinematic teeth growing up in Solano County's seat, making Super 8 movies that often starred friends doing rather dangerous stunts. After high school, Tenney went to the University of Southern California's School of Film and was enrolled in a class described by others as "filmmaking boot camp." Students had to create five films in one semester and show them to classmates.

Tenney shone and won a Student Emmy.

Witchboard explored the progressive entrapment of a person by a demonic force via a Ouija board. The main character in *The Exorcist*, Regan, went from zero to head-spinning, puke-spewing evil in no time flat, but Tenney's idea was to show the gradual process and do it in the context of a story with characters the audience cared about.

Witchboard is not a horror film. The approach is closer to *The Omen* than slasher movies like *Friday the 13th*, Tenney said in a March 1987 *Daily Republic* article. "Most horror movies have characters that do everything wrong which puts the audience at a distance. Viewers develop the attitude of 'I'd never do anything that stupid.' I make my characters do everything right and they still get killed. That's actually scarier."

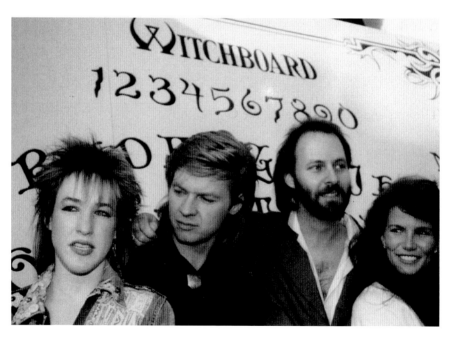

Witchboard publicity photo (*left to right*): Kathleen Wilhoite, Stephen Nichols, director Kevin Tenney and Tawny Kitaen. *Kevin Tenney.*

The cast featured actor Todd Allen (who later appeared in numerous television shows and movies), Tawny Kitaen and Stephen Nichols. Kitaen costarred in the 1984 Tom Hanks movie *Bachelor Party* and blew up right around the time of the release of *Witchboard* when she married David Coverdale, the founder/singer of heavy metal band Whitesnake, and appeared in the band's videos "Here I Go Again" and "Is This Love." Stephen Nichols won an Emmy for his fifteen-year role as Steve "Patch" Johnson on the soap opera *Days of Our Lives*.

Tenney also let some of his fellow Fairfielders get in on the act, not the least of whom was his brother Dennis, who wrote the music, including the film's featured song, "Bump in the Night," performed by Steel Breeze. James W. Quinn, a Fairfield High classmate, also had a prominent supporting actor role in the film.

The project took two years to complete and debuted on New Year's Eve 1986. The distributor released it to fifteen test markets, and it did well, so a nationwide release was ordered.

For a budget of about $1 million, the film grossed approximately eight times that amount at the theaters and later sold about eighty thousand videocassettes. That year, it was No. 18 on the *Billboard* Top 40 video rentals, between the Stephen King–penned *Stand by Me* and the Melanie Griffith vehicle *Something Wild*.

The setting for the film was Fairfield, but the economic realities were that the production had to be filmed in Southern California. Still, the local connection was exploited in teaser ads for the opening at the Solano Mall Theaters and later in the fall at the Chief Auto Movies. Ads featured a label stating, "Written and directed by Fairfield's Kevin S. Tenney."

Responses to the film were mixed locally, but it enjoyed positive reviews from the *Los Angeles Times* and *New York Post*, and it later progressed from an '80s guilty pleasure to a cult classic.

Unfortunately for Tenney, his memories around that time were tainted by tragedy. "I wasn't able to enjoy the film as much as I would have liked, because my father died in December when my brother Dennis and I were finishing up the post-production on it. Then the January when it opened in fifteen test markets, my grandmother died. So the only thing I really remember from that time period are funerals," Tenney said.

The impact of *Witchboard* exceeded anything Tenney could have imagined. "There's a guy who has a Ouija board museum in Salem, Massachusetts, and whenever someone does a film with a Ouija board, he is the on-set Ouija board expert. He can tell them a Parker Brothers Ouija board from

a certain year didn't look like this one, it looked like that one and so on. He became that because he loved the film *Witchboard* when he was a teenager. This guy has a whole life based on one film I made. I tell him all the time I refuse to be blamed for his life choices!" Tenney said.

Reflecting decades later, Tenney is able to see what he calls the film's flaws, many of which he saw back then, but he still looks back in love. "Like your first car, your first house and your first love, *Witchboard* will always be my first feature film and always hold a special place in my heart."

YES, THAT 1980 X-RATED MOVIE
WAS FILMED IN FAIRFIELD

So how is the 1964 Don Knotts movie *The Incredible Mr. Limpet* tangentially related to an X-rated movie that was at least partially filmed in Fairfield? More on that later.

In 2013, Elizabeth (Sheldon) Nessmith posted in the Facebook group "I Grew Up In Fairfield Too" about an interesting incident:

> *In the late 1980s, when my husband and I were stationed in Germany, he decided to spice things up and borrowed an X-rated video called "High School Memories" from some friends. One scene was on a school bus. I wasn't really interested in the subject matter, so I began looking out the bus windows at the scenery. THEY WERE ON HIGHWAY 12 (before the "new" bypass)! My husband didn't believe me. I said, "Watch, there's gonna be a 90-degree turn with a house set back from the road." The house came, but he still didn't believe me. It finally came down to the Fairfield sign. I said, "If they turn off 12 at Suisun City and go right then left at the light, and the Fairfield sign is there, you HAVE to believe me." He said, "Deal." I won the bet.*

Others corroborated Nessmith's account, but I was skeptical and didn't follow up on it. Then in January 2016, I met someone who wishes to remain anonymous who'd seen the movie. Later that year at the Tomato Festival, that same anonymous person informed me they'd discovered that the film was posted online.

I searched on Google and, sure enough, it was. *High School Memories* (1980) is about, well, people having sex, but the "plot" involves former high school friends reminiscing about fun they had back when, told in flashback sequences.

Now, I watched some of the movie, but only for research (wink, wink). I fast-forwarded to the bus scene and was floored when, just as Elizabeth Nessmith said, it turned down Union Avenue, then on to Texas Street.

As far as I know, the movie is no longer available to view online, although it is for sale. I was surprised by what I discovered online about the film. For instance, I had no idea that pornographic movies had Internet Movie Database (IMDb) pages, but they do.

The film's director, Anthony Spinelli, was supposedly one of the major directors of pornographic films during the "Golden Age of Porn" (circa 1970–84). I didn't know there was a "Golden Age of Porn" (or silver or bronze, for that matter). *High School Memories* was voted "Best X-Rated Movie" at the 1982 ViRA Awards, whatever those are.

Here's a fun fact: Spinelli (born Samuel Weinstein) was the younger brother of characteractor Jack Weston (Jack Weinstein), who had parts in many nonporn movies like *Can't Stop the Music* and *Dirty Dancing* and is probably best known by me and others as George Stickel in *The Incredible Mr. Limpet*.

There were several favorable online reviews, including this one: "'High School Memories' turns out to have a moral center. The hero starts off as a selfish jerk with no real regard for women. He grows into a decent fellow who appreciates and respects them as individuals. Here is a movie you can take your wife or girlfriend to see."

ALL THE KING'S MEN: THE KING OF MOVIES FILMED IN SOLANO COUNTY

There have been a number of major motion pictures filmed at least partially in Solano County, ranging from the good (*Tucker: The Man and His Dream* [1988]), the not-so-good (*The McCullochs* [1975]) and the ugly (*Howard the Duck* [1986]).

The local gold standard, however, has to be the 1949 film noir adaptation of Robert Penn Warren's Pulitzer Prize-winning novel about personal and political corruption, *All the King's Men*.

The film, loosely based on the story of real-life "Kingfish" Louisiana governor Huey P. Long, is basically about a seemingly ordinary "man of the people" getting swept into political office and becoming a ruthless demagogue.

The black-and-white film hits all the right notes, and its foundation is the wonderful source material by Warren, a novelist, critic, scholar and U.S. poet laureate.

Filming of a scene for *All the King's Men* on Tabor Avenue between Union and Fairfield Avenues. *Solano History Exploration Center.*

Robert Rossen wrote the screenplay and also produced and directed the film. Rossen's first choice to play the star of the movie, Willie Stark, was John Wayne. The Duke angrily turned down the role, as he felt the script was unpatriotic.

Broderick Crawford, who had done supporting roles until that time, was cast as Stark and plunged head-first into the role. His portrayal paid off, as he captured the Best Actor Oscar at the 1950 Academy Awards.

Mercedes McCambridge, in her film debut as brash, complex and compelling Sadie Burke, gave a riveting performance. She was in twenty-eight scenes, and her total onscreen time was about 21 minutes in the 109-minute film, but she also won an Oscar, for Best Supporting Actress.

McCambridge later provided the guttural, otherworldly voice of the demon Pazuzu that possessed Linda Blair's character in 1973's *The Exorcist*.

John Ireland, who starred as reporter Jack Burden, was nominated for Best Supporting Actor but did not take home the statuette. Joanne Dru (elder sister of *Hollywood Squares* host Peter Marshall) turned in a fine performance as Anne Stanton.

Parts of the film were shot in Suisun City, Fairfield, Stockton and other locales. Rossen made the then-unheard-of decision to use local folk as extras.

The old Suisun Plaza, which used to be the spot for Fourth of July festivities back when, is clearly identifiable in a scene near the beginning of the film. In the scene, Stark is speaking to a crowd of people and is told by an officer that he is not allowed to do so as per a city ordinance. Stark then tells his son (played by a young John Derek) to pass out handbills after being told that that, too, was illegal, and he is arrested.

A.C. Tillman was the sheriff of Suisun City at that time and plays the officer that warns, then arrests, Stark. Tillman has an Internet Movie Database (IMDb) credit for the role.

Willie Stark's house in the film was one owned by Richard Oliver and was located on Tabor Avenue, across the street from where the old water tower used to be. The filmmakers took photos of the interior of the house, then built sets inside the M&M Skateway in Suisun City (located near the present-day Athenian Grill).

Will Wright, a well-known character actor, played Dolph Pillsbury in the film. Wright appeared in more than two hundred films and had a recurring role as skinflint store owner Ben Weaver in TV's *The Andy Griffith Show*. He is buried in the Suisun-Fairfield cemetery on Union Avenue.

The old Crystal Elementary School is shown in a pivotal scene, and the teacher in the class was a Mrs. Hindman. She and her husband (who is also in the film) later owned Hindman's Antique Store in Suisun City.

Many locals met and took pictures with and got autographs from the film's stars. It was heady stuff to have a Columbia Pictures movie being produced here.

The United States National Film Registry of the Library of Congress chose the film for preservation in 2001, as it was deemed to be "culturally, historically or aesthetically significant."

In addition to the Academy Awards won by Crawford and McCambridge, *All the King's Men* also took home the 1950 Oscar for Best Picture.

DO YOU REMEMBER?

When Voici was one of the swankiest restaurants in Fairfield?

Ordering items at catalog stores Ardan and Consumer Distributing?

The gas station in the Wonder World parking lot with the terrible name Terrible Herbst?

The delicious if odd-shaped ice cream cones at Thrifty's?

Cutting fruit as a summer job in Suisun Valley?

The Firehouse Deli that had a salad bar in a bath tub?

The donkey General Jackson that was down Fairfield Avenue past the water tower?

Blue Light Specials at Kmart?

All of the homemade costumes at the annual Halloween parade down Texas Street?

Donkey baseball at Lee Bell Park where players had to "run" the bases riding beasts of burden?

Sidewalk sales?

Sassafras Old-Fashioned Ice Cream Parlor, downtown kitty-corner to the Fairfield Cinema I?

Aquarius Gifts, whose gifts kept it out of the realm of just another head shop?

Ordering a sandwich by number at Big John's Sub Shop?

9

REMOVING THE
ROSE-COLORED GLASSES

*Y*ou can't go home again" is a saying referring to a common experience: If you move away from a place with cherished memories, it will never be the same when you return. Over the years I have seen people who lived in Fairfield thirty, forty or fifty years ago return and bemoan the fact that it is no longer a small town and has, as many cities of over 100,000 people do, problems with crime, homelessness and other challenges.

That said, I have seen those same people engage in a phenomenon I call the Mayberryization of Fairfield. To be sure, there were obviously fewer problems when there were fewer people, but from what I have gleaned from primary sources like microfilm and from the experiences of those who were here at the time, reality is a different story. Once the rose-tinted glasses are removed, Fairfield was much less like the town in *The Andy Griffith Show* and more like the real-life-happened-but-folks-didn't-talk-about-it town in the movie *Pleasantville*.

When it came to race relations, there were Hispanics and Asians who lived in Fairfield and Suisun Valley, though there very few African American residents until Travis Air Force Base was built. Early twentieth-century editions of the Armijo High School yearbook *La Mezcla* feature a joke section. There are a few derogatory references to Black people that mimic the stereotypical caricatures perpetuated in the radio/TV show *Amos 'n' Andy*. In at least two yearbooks, the n-word is used in "jokes."

The cover of the 1914 Armijo yearbook, containing a racial slur in the jokes section. *1914 Armijo High yearbook.*

Television talk shows and social media have shined some daylight on many societal problems, but that was not the case back in the day. A local who passed away a number of years ago, Barbara Macy Cordy, posted in the "I Grew Up in Fairfield Too" Facebook group about some of her experiences in Solano County's seat. While she was unscathed (her word), she knew, as many others did, about things that happened in town that people just did not talk about publicly.

Cordy wrote: "Bad things that happened in our homes in those days were considered private family matters. In grade school, a father molested his daughters, impregnating his eldest; there was an attempted kidnap of a young girl—the man claiming he was sent by her parents; a teacher locked a child in a closet and left her there most of the day, another teacher tied a child to a chair—the child freaked out and injured himself. It was 'frowned upon' to date a boy with long hair or to date someone with a different skin tone; people remained in the closet about their sexuality; those with disabilities were shunned as were those who had children out of wedlock. I could go on and on."

Another local, Bobby Morris, concurred. "The 'good ole days' weren't as innocent and carefree as we would like to remember. There was a lot of stuff that happened that was considered private matters that wasn't talked about. A 'sweep it under the carpet and hope everything works out' type of attitude was prevalent," Morris said. "I'm still glad I grew up in Fairfield. I have way more good memories than bad, and I think the bad ones helped teach me about life."

RACE RIOT AT TRAVIS

On May 22–25, 1971, race riots broke out at Travis Air Force Base. The fighting began when 35 to 75 Black servicemen congregated and expressed

anger over the confinement of 2 Black airmen who had been in a fight at the NCO Club. Eventually, there were 135 arrests, 10 people were injured and one civilian firefighter was killed.

Former Suisun City resident and 1973 Armijo High grad Bill Mackie said that when he later joined the U.S. Air Force, the riots were a topic in mandatory race relations classes.

Some locals didn't appreciate how good race relations were here until they left. After his freshman year at Armijo, navy brat Al Cacioppo moved to Bremerton, Washington, as a sophomore and then to Summerville, South Carolina, for his junior year.

"The year was 1965. Being a California teenager, it was hard to understand the hate and prejudice all around me," he said. "The Tastee-Freeze I worked at would not serve 'colored' inside, only at the walk-up window, and the high school I attended was all-White. I wasn't that popular there mainly because I was friends with a Black teenager who was the dishwasher at the restaurant. After that 'adventure' we moved back to Fairfield and I graduated with the class of '67. My old Armijo classmates said I talked funny upon my return."

Carl Lamera had an amusing story about local race relations. "We were a multicultural 'hood. My brother Ben (Filipino), Greg Johnston (White) and Darryl Scruggs (Black) were going out on a triple date with some gals of similar multiracial backgrounds," he said. "At the Scruggs' house, Darryl's mom went on to say how messed up they were in matching up, and physically rearranged the dates so that the races matched."

Mexican American Mural at Armijo

During the summer of 1980, several students from the Mexican American Youth Organization (MAYO) painted a mural featuring scenes from Mexican American history on the A Wing wall facing Washington Street. The eye-catching mural was the handiwork of Celestino Galabasa.

Galabasa was not an Armijo student—he lived in Rio Vista—but he had cousins in MAYO. "They knew I knew how to draw so they recruited me," Galabasa said. "Raquel Ortega Rodriguez headed the whole thing and she went to the school and got the approval."

Since the canvas they were using was a wall, there were some obstacles. There was a bell and a grating that had to be somehow incorporated into the piece. The bell became a sun and the grate was used in a clever way.

The Mexican American Youth Organization (MAYO) mural that was once painted onto a wall at Armijo facing Washington Street. It was defaced repeatedly. *1981 Armijo High yearbook.*

"We made it the grill of a truck. It was the one owned by my cousin Cathy Ortiz, and she was painted in driving it," Galabasa said. "If you look at the license plate it says 'BABA' because we used to call her 'Baba Looey.'"

The mural depicted people from Mexico's history, including revolutionaries Emiliano Zapata and Don Miguel Hidalgo y Costilla. It also included a poem called "The Chicano" and a caravan of vehicles featuring, like Galabasa's cousin, real vehicles of MAYO members and the members themselves.

"There is a '66 Chevelle, and that was my car. I'm in that car and my girlfriend at the time is in the car with me and her little sister, too," Galabasa said. "It was a fun summer."

The mural was dedicated to the Armijo student body on September 27, 1980. Many students of all races enjoyed it, but vandals repeatedly defaced it with paint.

While not condoning criminal behavior, Galabasa could understand why some may have wondered why there was a mural depicting only Mexican American heritage and not others. Still, Armijo did have other walls. Panels were touched up and even changed after being vandalized.

"Where an Aztec calendar once was, I instead added a guy in a Zoot suit with a really sexy lady," Galabasa said. "I also tried to incorporate faces of people from different races to try and make it more multicultural."

The repeated vandalism to the mural was devastating to MAYO club members.

"Monday would come and we would go to school and hope that the mural was still intact. I remember how disappointing it was when we would get there and it would be defaced again," MAYO member and class of 1984 graduate Margarita Lopez said. "It was very upsetting. Some of us were angry and some of us were scared. We wondered what was going to happen next. Was there going to be some sort of a fight?"

No matter how many times it was touched up and repainted, the mural was repeatedly vandalized. The 1981 Armijo *La Mezcla* yearbook featured a gatefold picture of the then-new mural, and the next year's edition included a picture of it defaced with paint.

Eventually, the MAYO mural was painted over, and today many don't know it was ever there.

THE SPY THAT WENT TO ARMIJO HIGH

While modern-day senior superlatives in high school yearbooks may include categories like "Most Likely to Become a Social Media Star" and "First to Die in a Zombie Apocalypse," they still often feature old-school superlatives like "Most Athletic" and "Most Popular" that were in yearbooks over sixty years ago.

However, neither Eisenhower-era annuals nor twenty-first-century yearbooks include "Most Likely to Commit Espionage." It's unlikely that James Durward Harper would have been chosen for that "honor" in the 1952 Armijo High *La Mezcla* yearbook, yet three decades after graduation, he became the spy that went to Armijo High.

On October 15, 1983, the FBI arrested Harper, then forty-nine and working as a freelance electrical engineer in Mountain View, California. He was charged with selling Minuteman missile secrets to the Soviet Union over an eight-year period.

Harper's wife, Ruby Louise Schuler, worked as a secretary for a defense contractor in Palo Alto that did research on ballistic missiles. While Harper did not have a security clearance, his wife did. He copied classified documents at night and on weekends and then, between July 1979 and November 1981, passed them on to Polish intelligence officials, who in turn passed them on to the Soviet Union's security agency, the KGB.

Ruby Louise Schuler escaped prosecution, as she died of cirrhosis of the liver at age thirty-nine, four months before Harper's arrest.

Harper was paid $250,000 (over $650,000 in 2021) for the approximately one hundred national defense secrets he stole. The Soviet agents involved in procuring them were given commendations by KGB leader Yuri Andropov.

An FBI affidavit stated that the extremely sensitive research by the Department of Defense involved the ability of the United States' Minuteman missiles to survive a preemptive nuclear attack by the Soviet Union.

Whether he was motivated by twinges of conscience or a fear of prosecution is unclear, but in September 1981, Harper attempted to broker a deal for immunity anonymously with the CIA, through an attorney. That offer was rejected, and Harper continued to sell secrets. He was later identified by a Polish double agent.

The story broke nationally and was printed in the October 18, 1983 *Daily Republic* with the headline, "Bay Area Man Held in Sale of U.S. Secrets." It quickly became clear within a few days that the spy identified initially just as a "Bay Area man" was from Fairfield.

When Harper was growing up, his parents had separated, and while that is rather common these days, in the early 1950s in small-town Fairfield, it was not. A friend who knew Harper back then was quoted anonymously in the *Daily Republic* in 1984: "He had the typical problems a boy without a father has. When he went astray there was no one to kick him in the fanny. His value system was screwed up."

While at Armijo, Harper played football, basketball and ran track. He excelled as a fullback for the Indians but broke his leg in the first game of his senior year and sat out the season. He was named honorary captain and had to watch as his teammates won the Superior California Athletic League championship that year.

Descriptions of Harper by classmates included "brilliant," "a loner," "self-centered" and "cocky."

By the 1970s, Harper was an ex-marine and started a company called Harper Time and Electronics that developed the first digital stopwatch. The company he founded eventually ousted him in 1974 and went bankrupt because of his erratic behavior and loose business practices. The patent rights to the digital stopwatch were included as part of the company assets and were sold to a couple of entrepreneurs after the bankruptcy.

James Harper was sentenced to life in prison on May 14, 1984. Presiding federal judge Samuel Conti told Harper, "You are a traitor to your country who committed the crime not for any political reasons, but for greed."

The story has a couple of interesting side notes.

Harper later successfully petitioned a federal court to have the government return property seized during their investigation—including a teddy bear.

John Walker, another American spy, coincidentally used the alias "James Harper" when selling secrets.

Harper, who was known as 75856-011 at the United States Penitentiary in Lompoc, California, was released on February 26, 2016, at age eighty-two.

WHERE IS FAIRFIELD?

*O*n April 7, 1995, a public art project called "Where Is Fairfield?" was launched in the Solano County seat. It kicked off with a banner flown over the city during the morning rush hour.

The question was asked in standard and unexpected ways so that everyone who lived and/or worked in the city had the opportunity to respond in some way. The object was to heighten awareness of existing characteristics in the city of Fairfield as well as to celebrate new ones. The goal was for it to be asked in every classroom in every school in the city, printed in the newspapers, displayed on movie theater marquees, asked of radio listeners, engraved in the bricks in downtown Fairfield, printed on grocery bags, painted on selected walls and projected on buildings at night.

The project was spearheaded by Fairfield Civic Arts coordinator Shelly Willis-Scholtes and cofounders Lauri Kimberly and Jody Nash.

"Where is Fairfield?" returned the following year and was expanded into a festival with vendors and music encircling the man-made pond behind City Hall. It continued annually for a few years and eventually faded away. Today, the only remnants are bricks in front of Joe's Buffet and in the Downtown Theatre courtyard.

The question, however, still remains. The obvious (and literal) answer is that Fairfield is smack dab between San Francisco and Sacramento. It is also home to Travis Air Force Base and the Jelly Belly factory. However, on a deeper level, the Fairfield that exists for many folks is not the physical one of today, but of the mind, of memories.

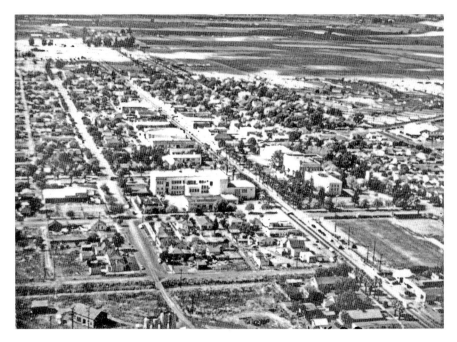

An undated aerial photograph of Fairfield. *Vacaville Heritage Council.*

To be sure, as Thomas Wolfe once said, you can't go home again. I have read posts in the "I Grew Up in Fairfield Too" group from people who moved away decades ago who are completely shocked that Fairfield did not remain pristinely frozen in time just as they remembered it. The city has grown exponentially, and there is resultant crime and homelessness and other issues that cities struggle with.

I am a glass-half-full person, and I have seen wonderful people who volunteer their time for the community. I have joined their efforts. I remember a number of years ago that the annual downtown Fourth of July parade was to be canceled, and the community stepped forward to save it. I half-jokingly said I would volunteer as a pooper scooper if need be. They took me up on that, and I have helped a local Boy Scout troop do just that for a number of years.

At that particular Fourth of July parade and at subsequent events, I have seen the true spirit of Fairfield given hands and feet. The entire spectrum of Fairfield residents, young, old, veterans, members of African American fraternal organizations, Sikh temple members, Hispanic horse-mounted clubs and so many more coalesced as one.

So, does Fairfield have problems? Absolutely. But does that unique flavor still exist? I believe it does and is nurtured by many folks.

Where is Fairfield? It will always be right here in my heart.

BIBLIOGRAPHY

Books

Armijo High School. *La Mezcla* yearbooks. Fairfield, California. Various years.

Fairfield High School. *Talon* yearbooks. Fairfield, California. Various years.

Fraser, Munro J.P. *History of Solano County 1879*. Solano County, CA: public domain, 1879.

Goerke-Shrode, Sabine. Images of America: *Fairfield*. Charleston, SC: Arcadia Publishing, 2005.

Weir, David. *That Fabulous Captain Waterman*. Fairfield, CA: public domain, 1957.

Websites

City of Fairfield Resolutions and Ordinances. https://www.fairfield.ca.gov/gov/city_council/resolutions_and_ordinances.

Facebook. "I Grew Up in Fairfield Too." https://www.facebook.com/groups/fairfieldyears.

Historical Articles of Solano County Online Database. http://www.solanoarticles.com/history/index.php.

Solano History Exploration Center. http://www.solanohistorycenter.org.

Vacaville Heritage Council. https://www.vacavilleheritagecouncil.org.

Video

Fairfield, California: Our History. City of Fairfield, California, 2003.

Microfilm

Daily Republic microfilm, Fairfield Civic Center Library.

INDEX

ABOUT THE AUTHOR

*T*ony Wade came to Fairfield in 1976 when he was twelve and never left. He attended Grange Intermediate, Armijo High School and Solano Community College. In 2006, Wade began writing columns for the local newspaper, the *Daily Republic*, as a freelance writer. In 2011, he became an amateur historian when he began writing his Back in the Day columns for the *Daily Republic*. He is the older brother of longtime *Daily Republic* columnist Kelvin Wade and lives in Fairfield with his wife, Beth, and their Chiweenie, Chunky Tiberius Wade.

Visit us at
www.historypress.com